Sexy Anime Girls

Coloring Book for Grown-Ups 1 & 2

UNCENSORED

ColoringArtist.com

Copyright © 2017 - Nick Snels
Cover by Slamet Hariyadi
http://www.coloringartist.com

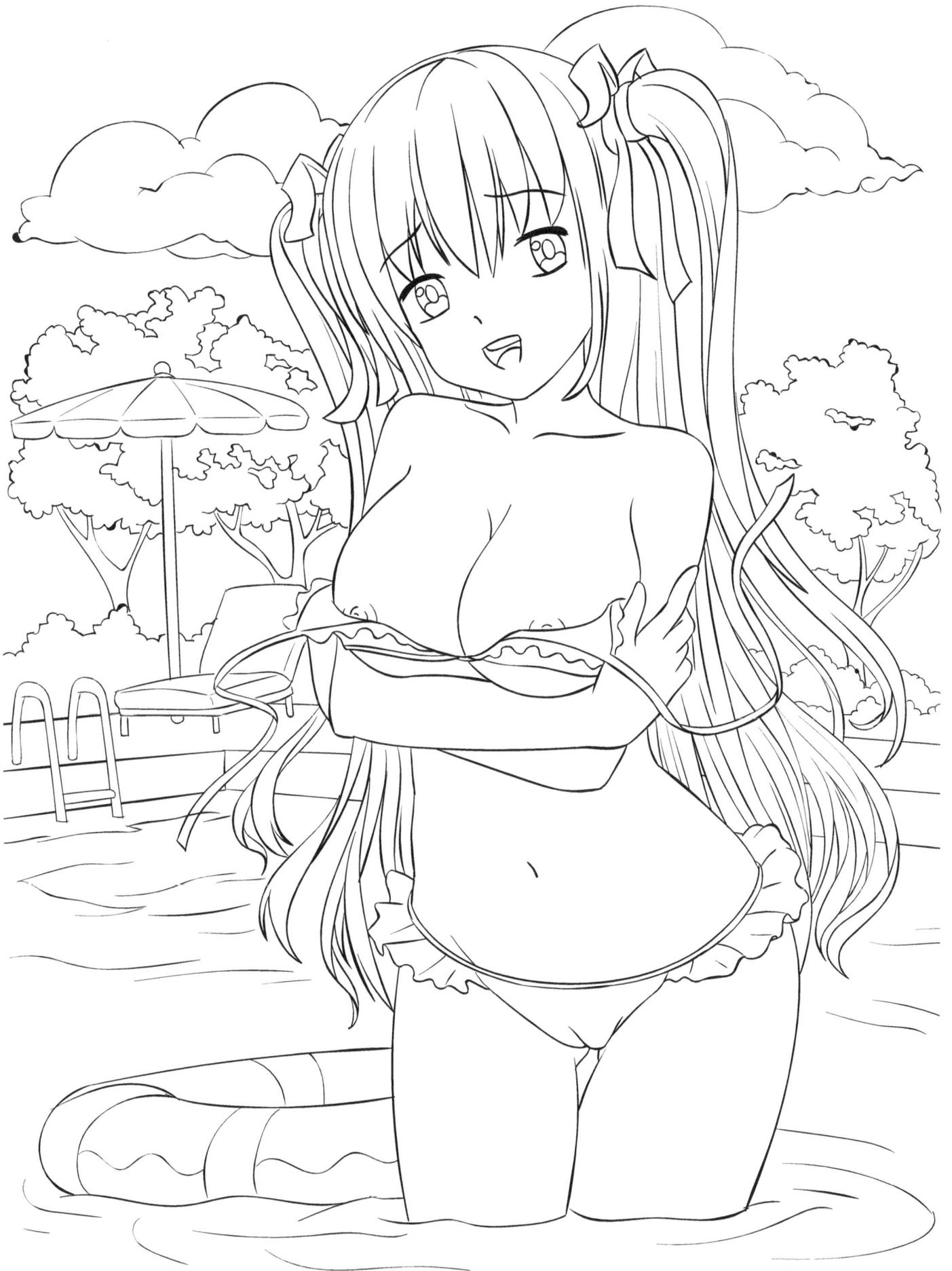

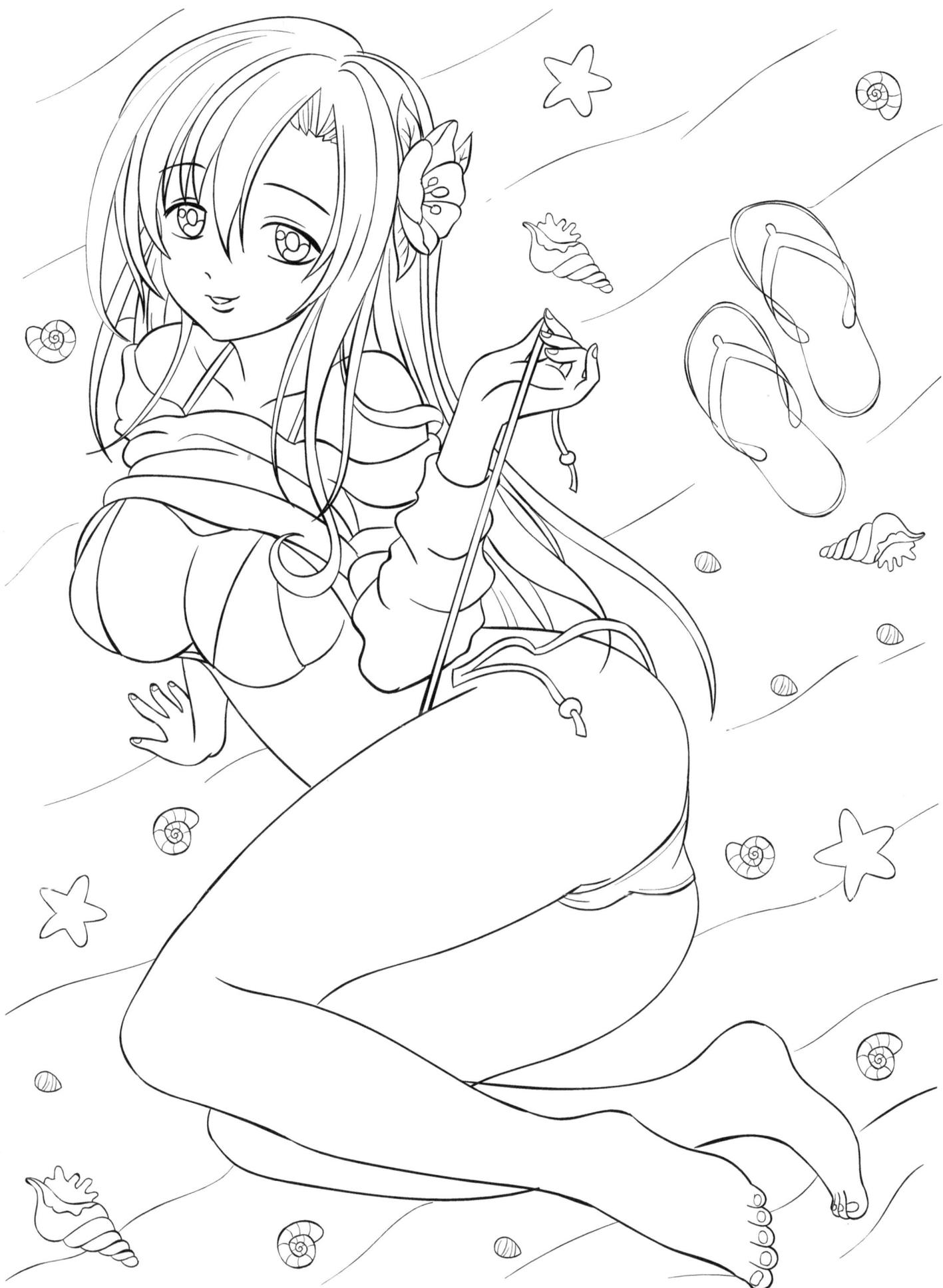

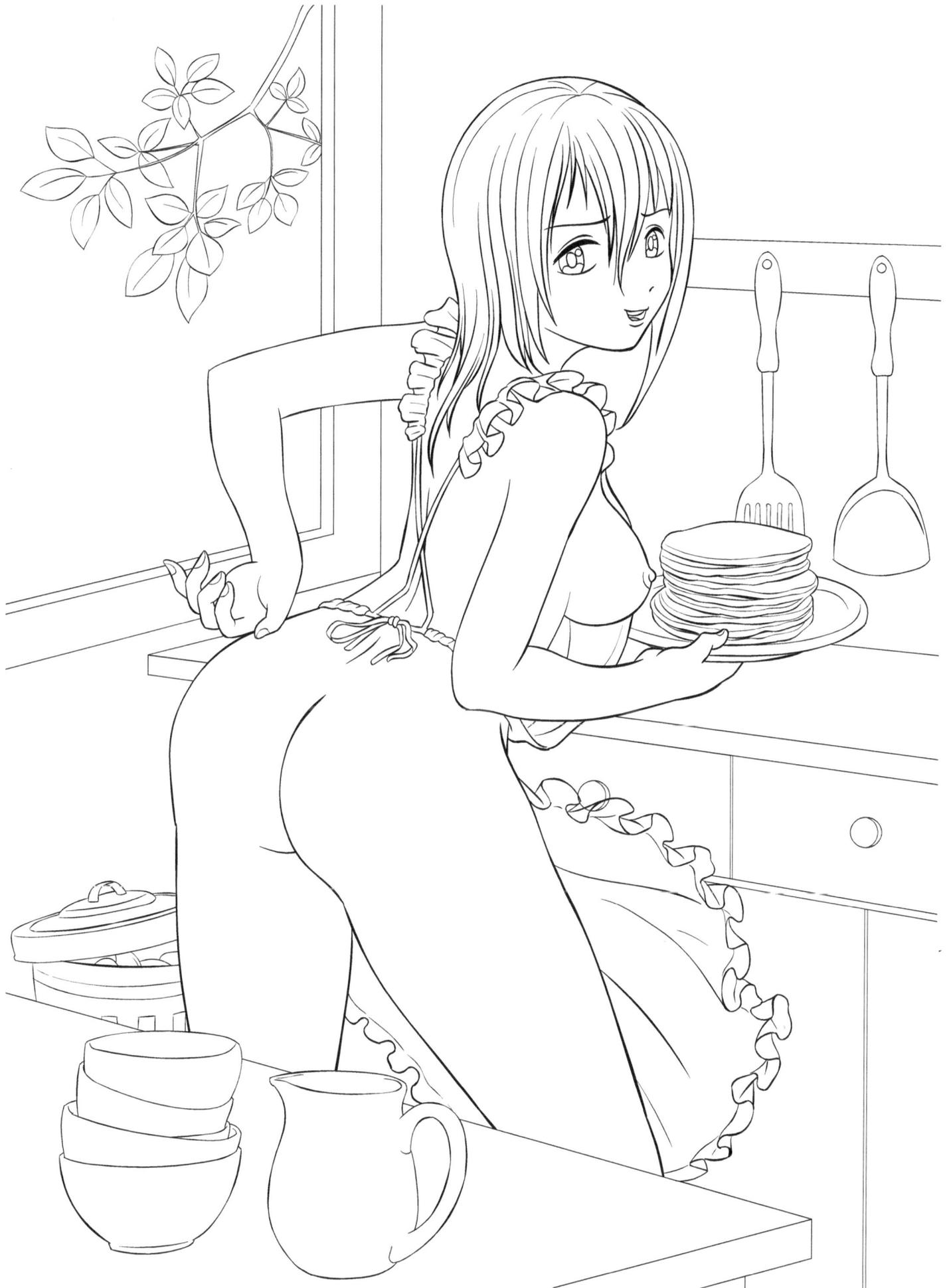

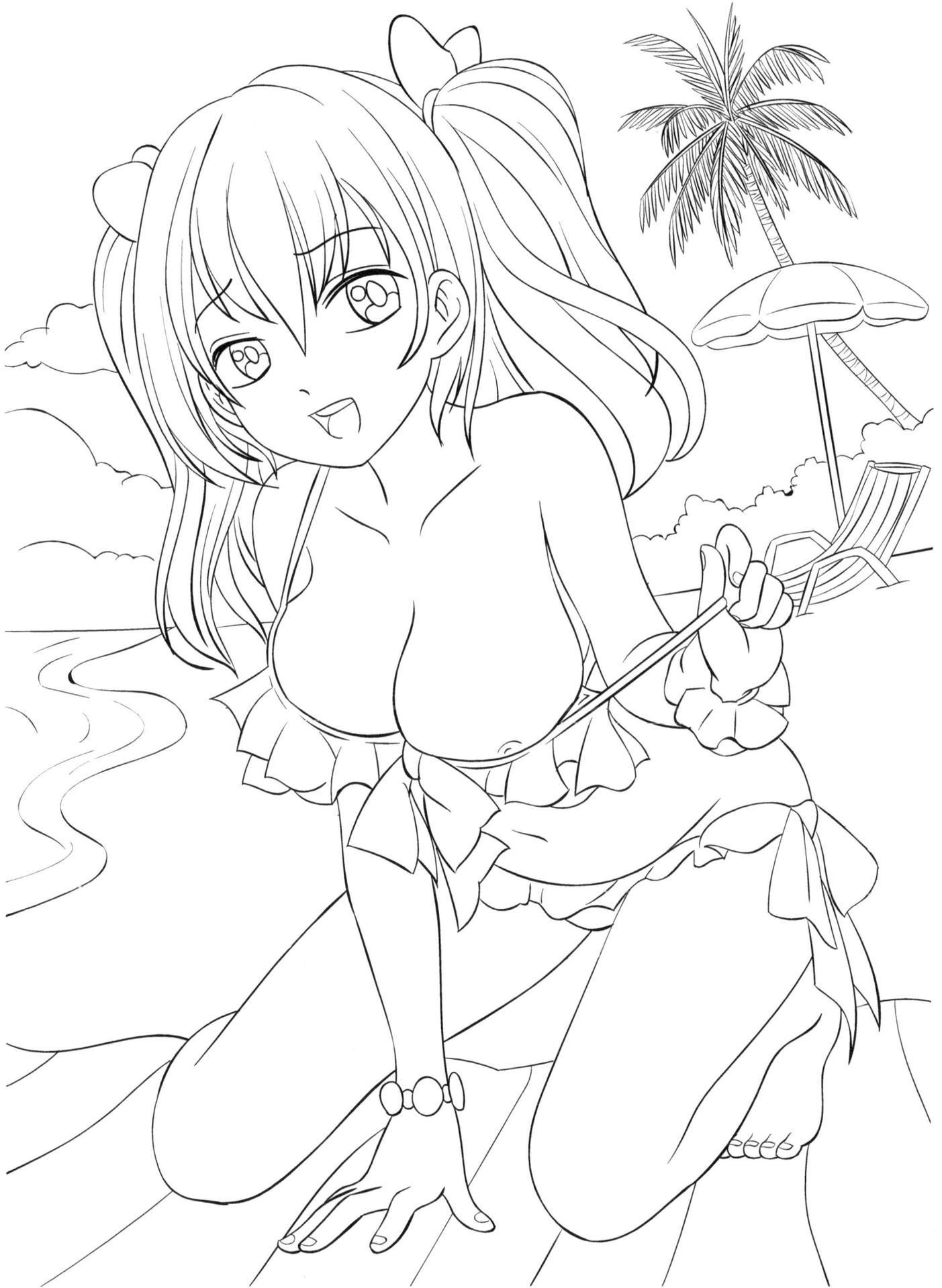

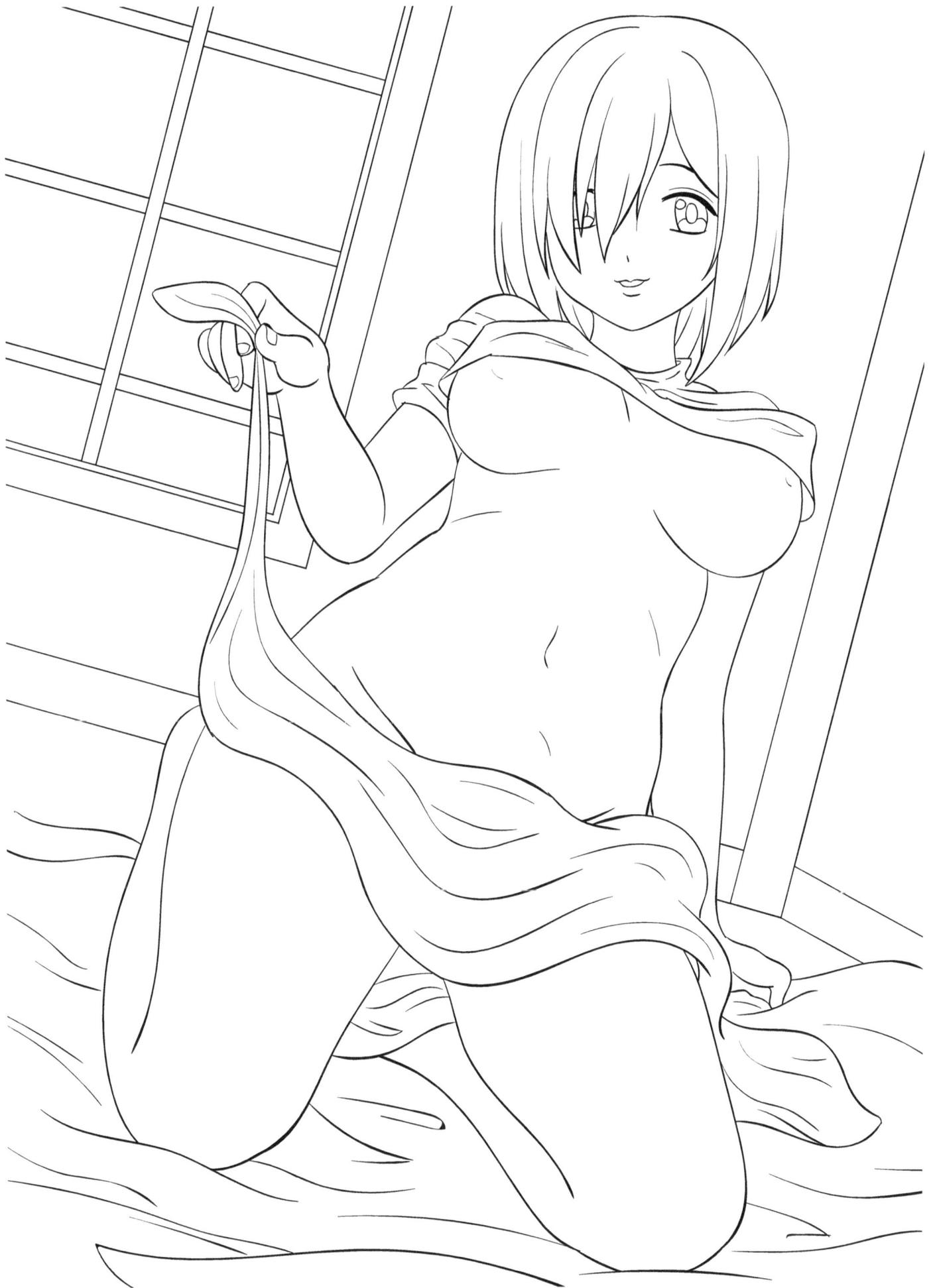

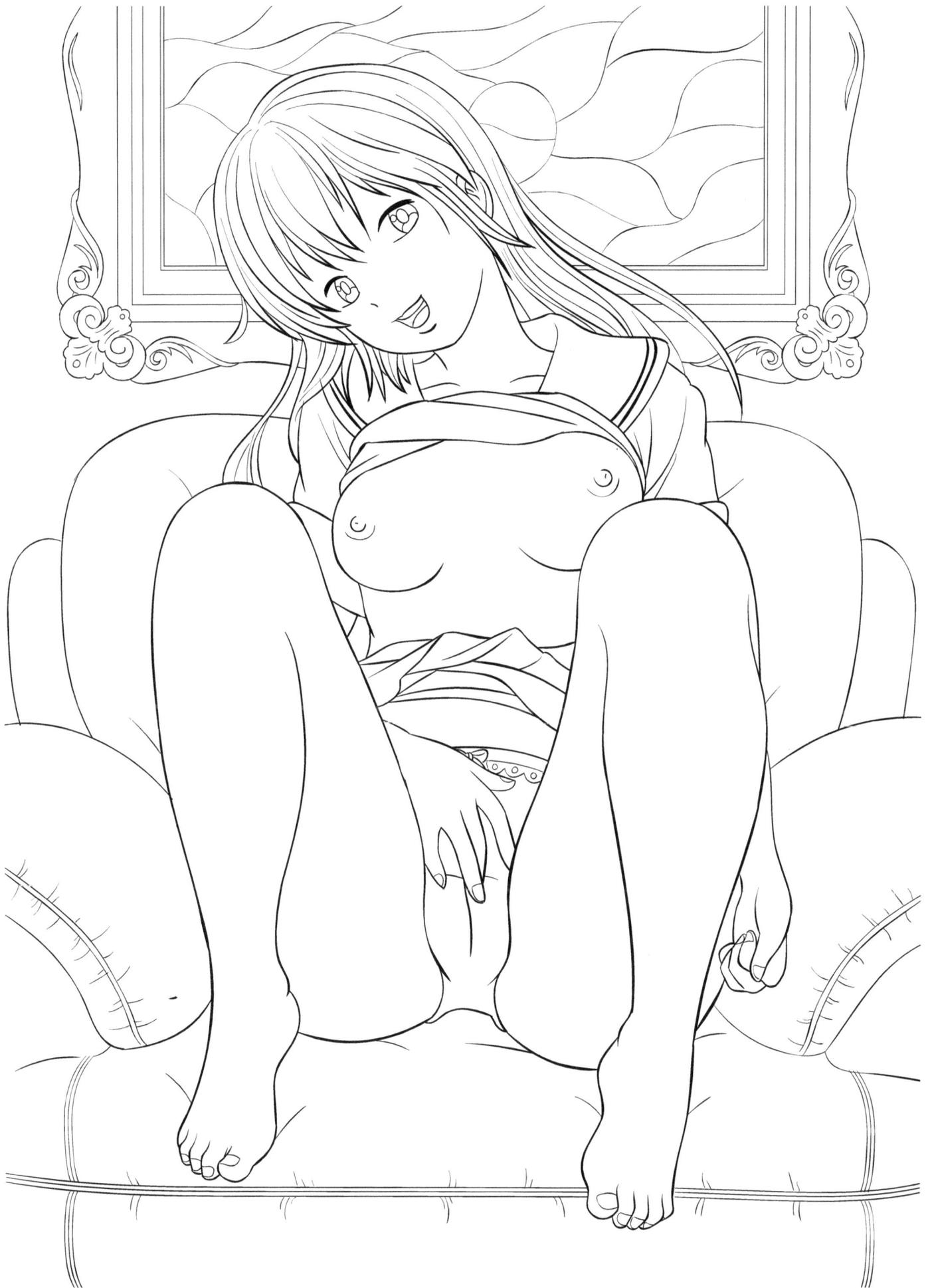

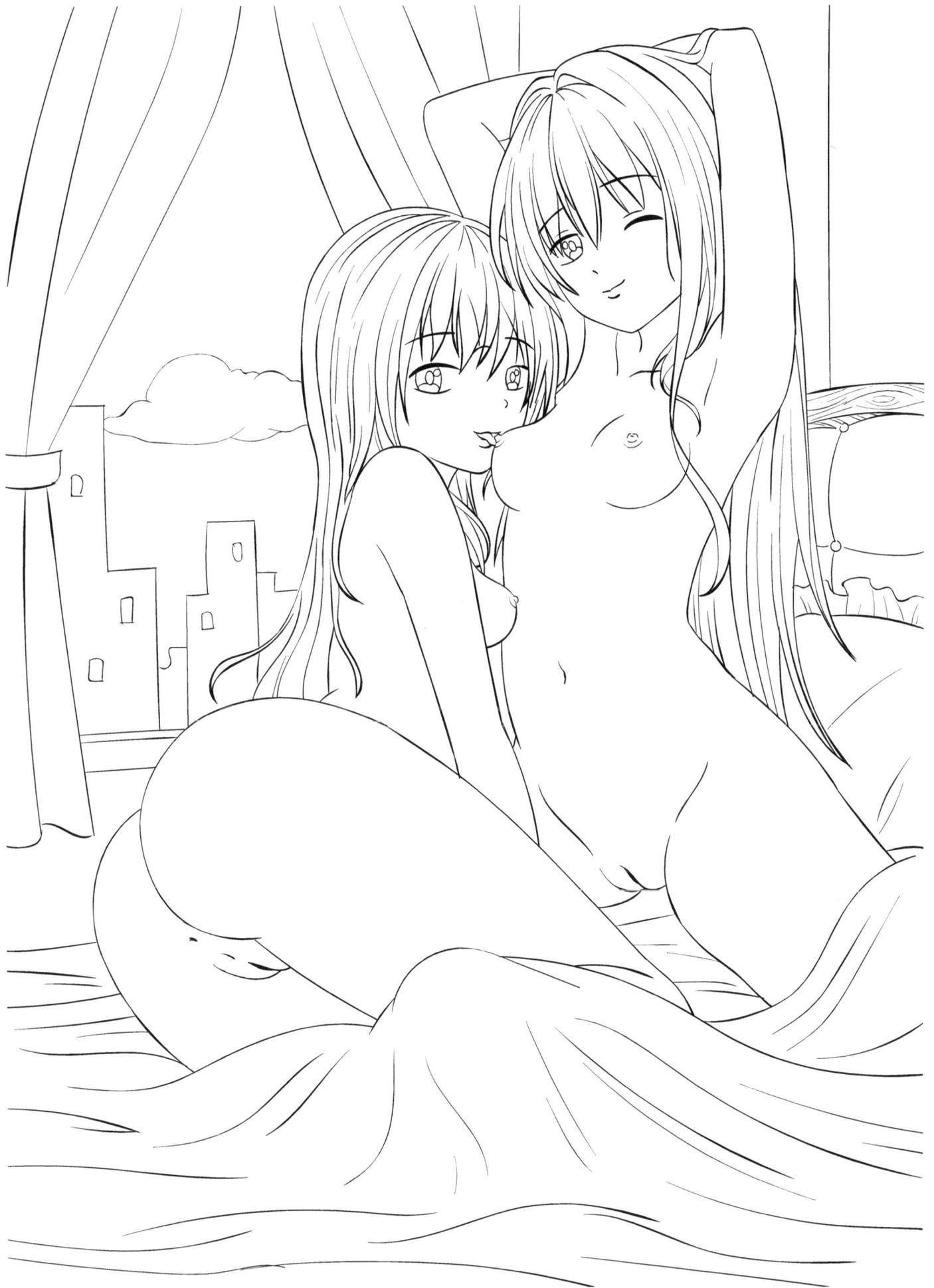

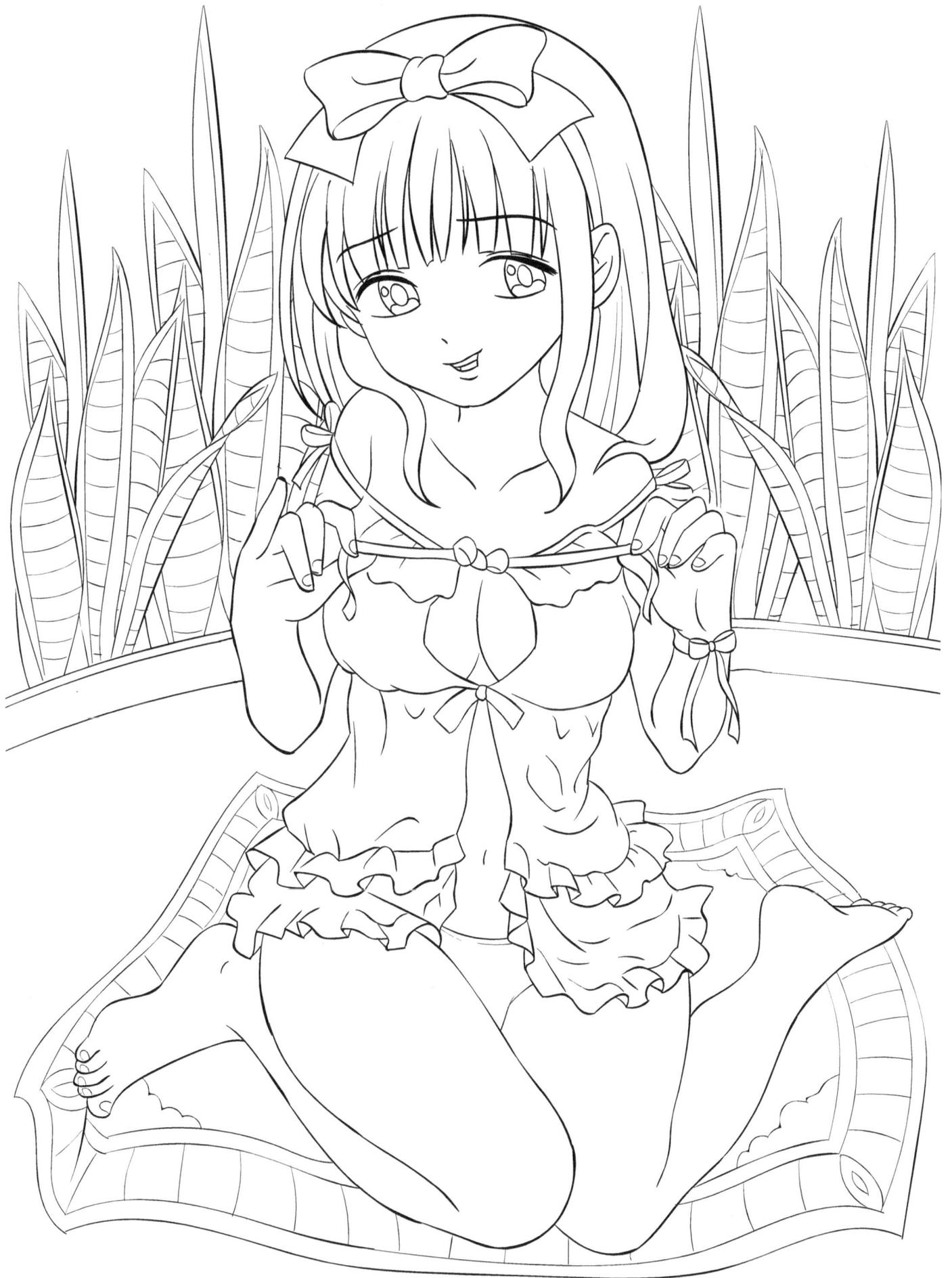

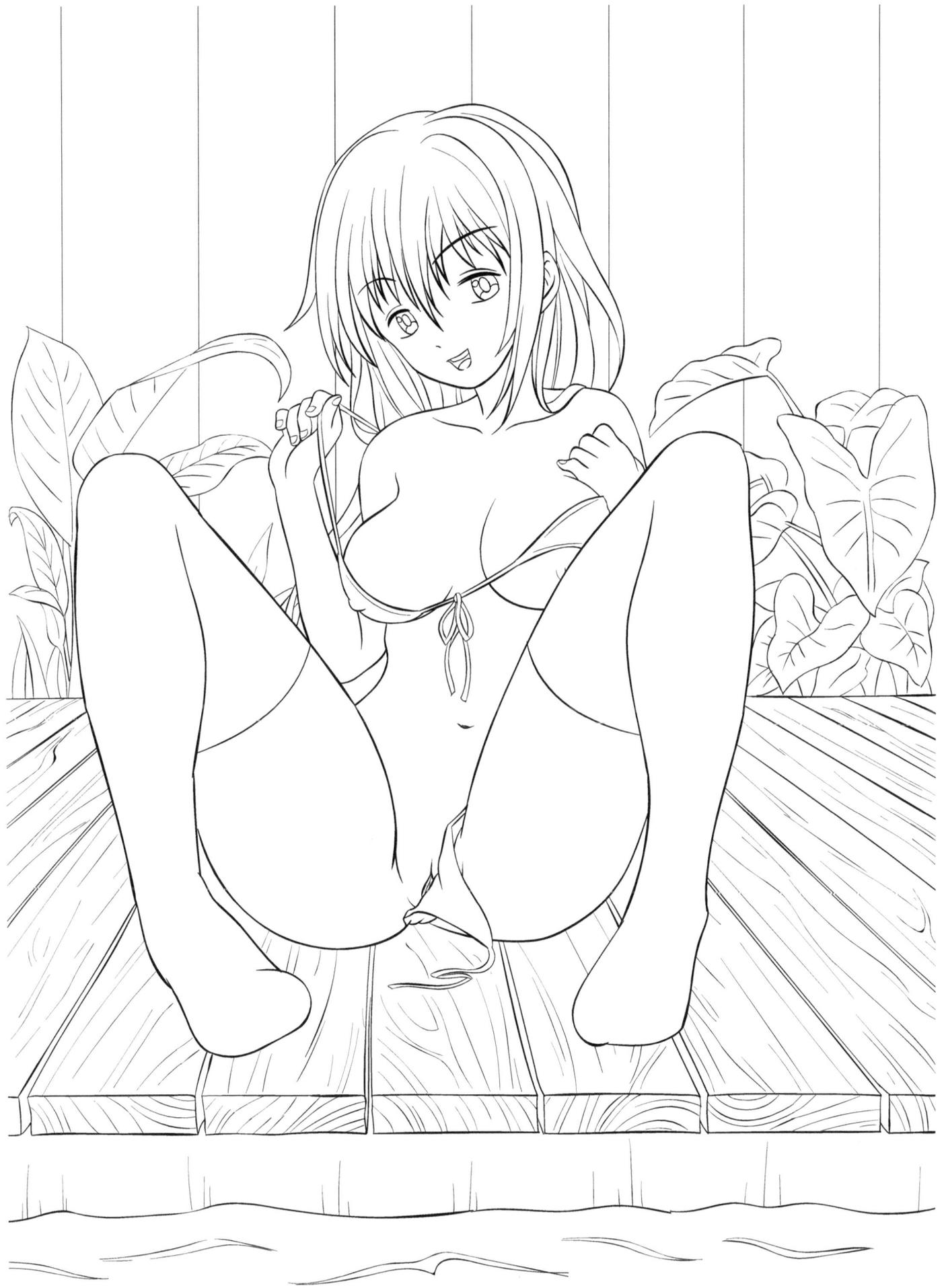

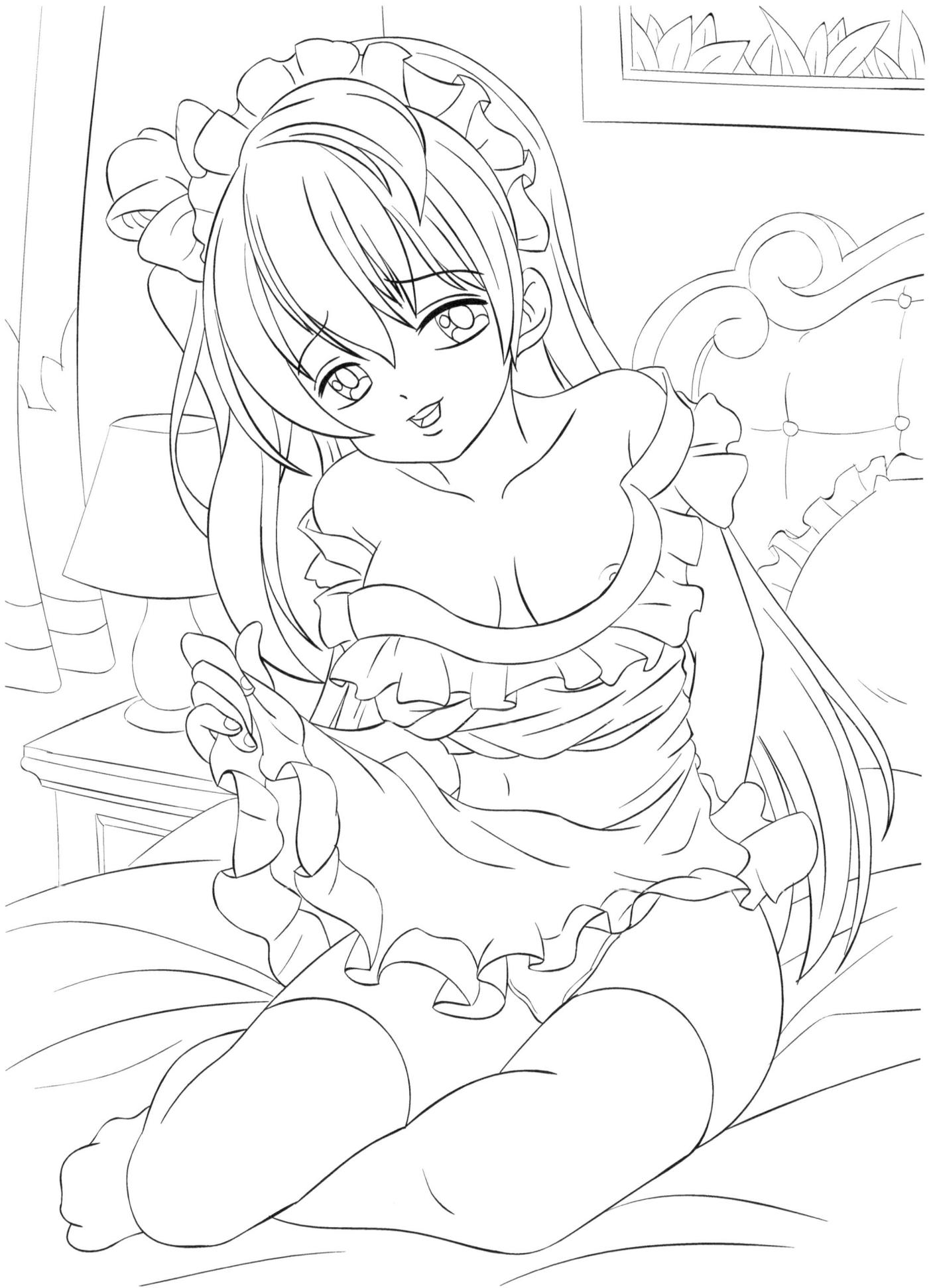

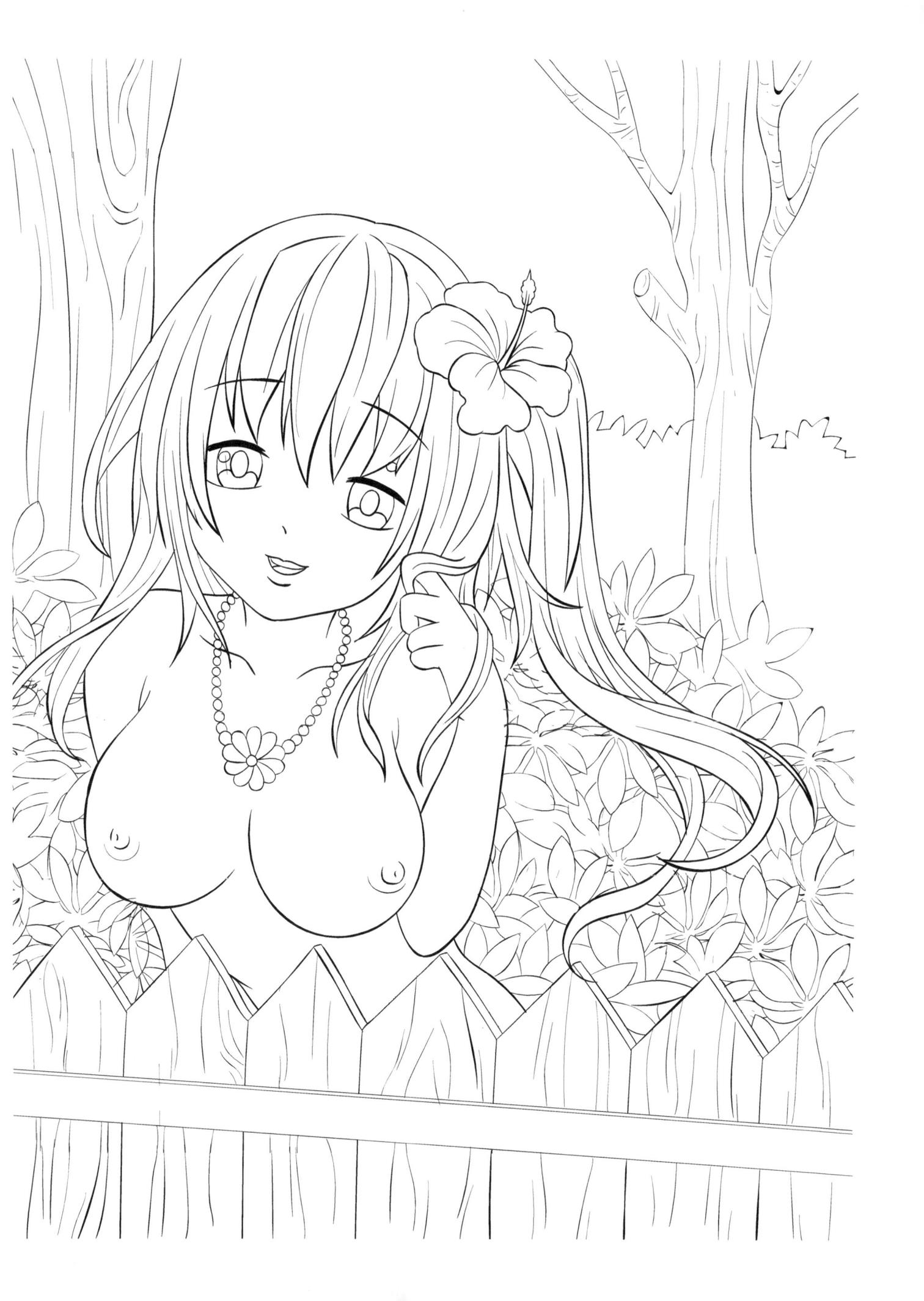

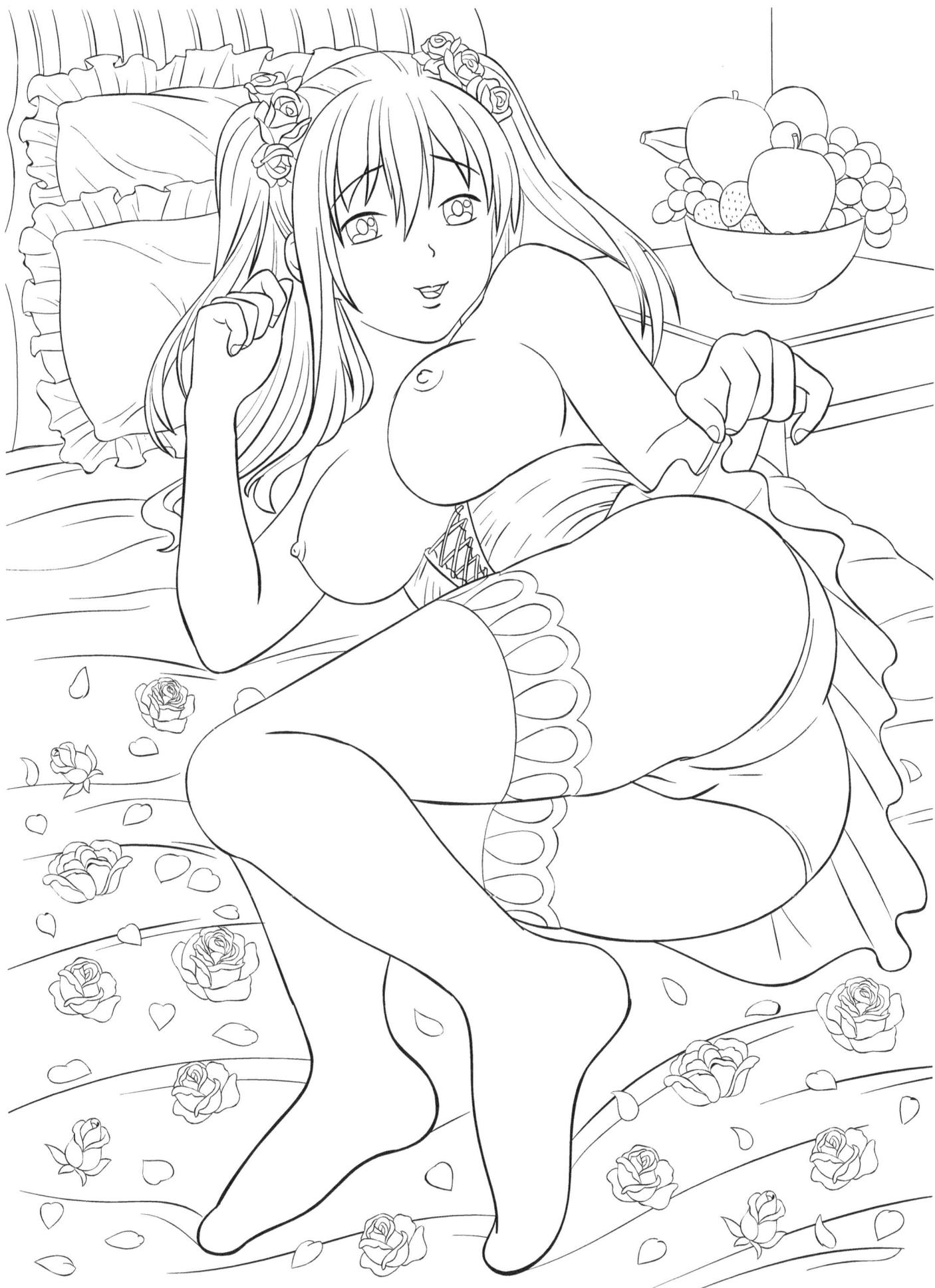

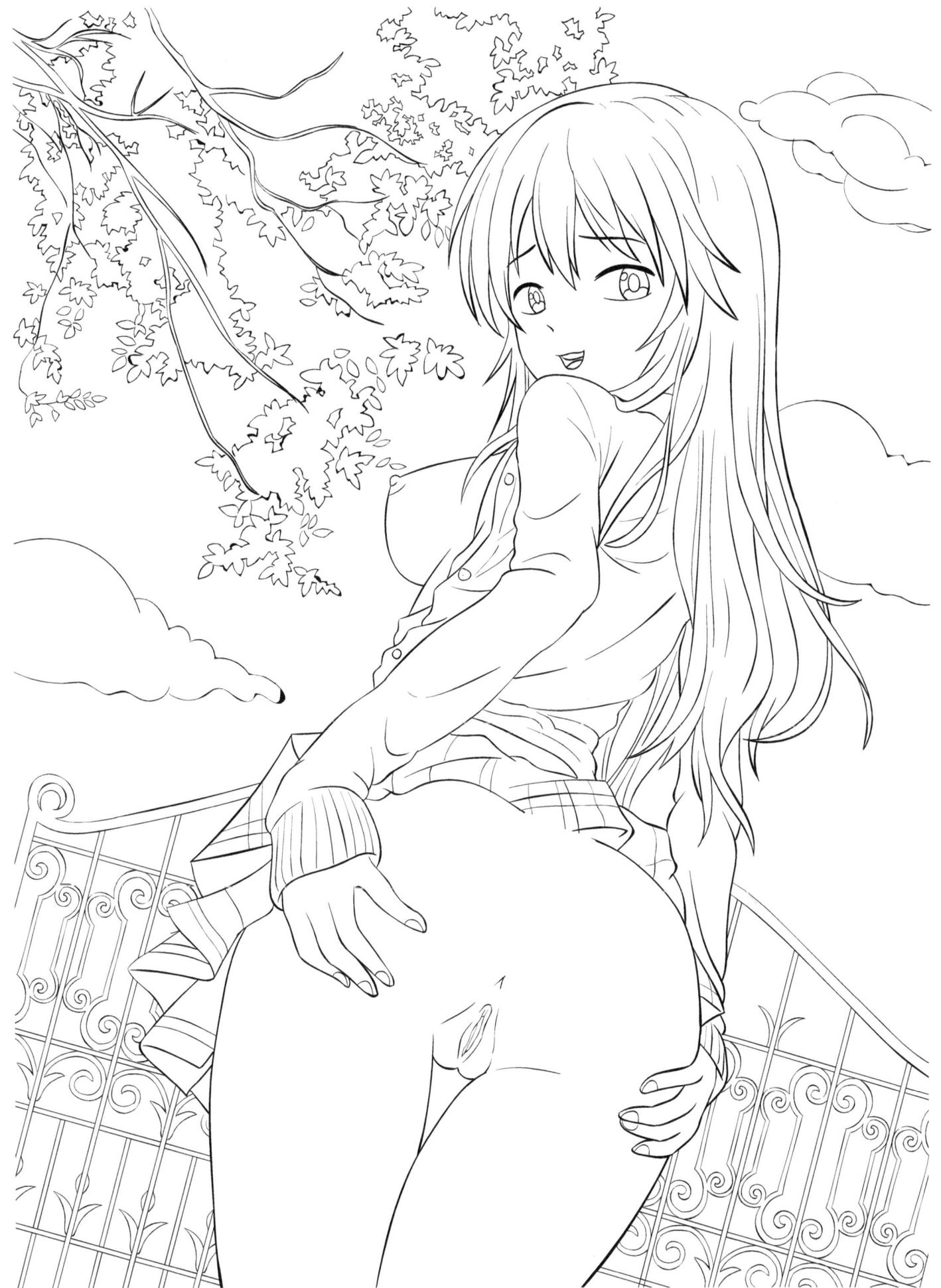

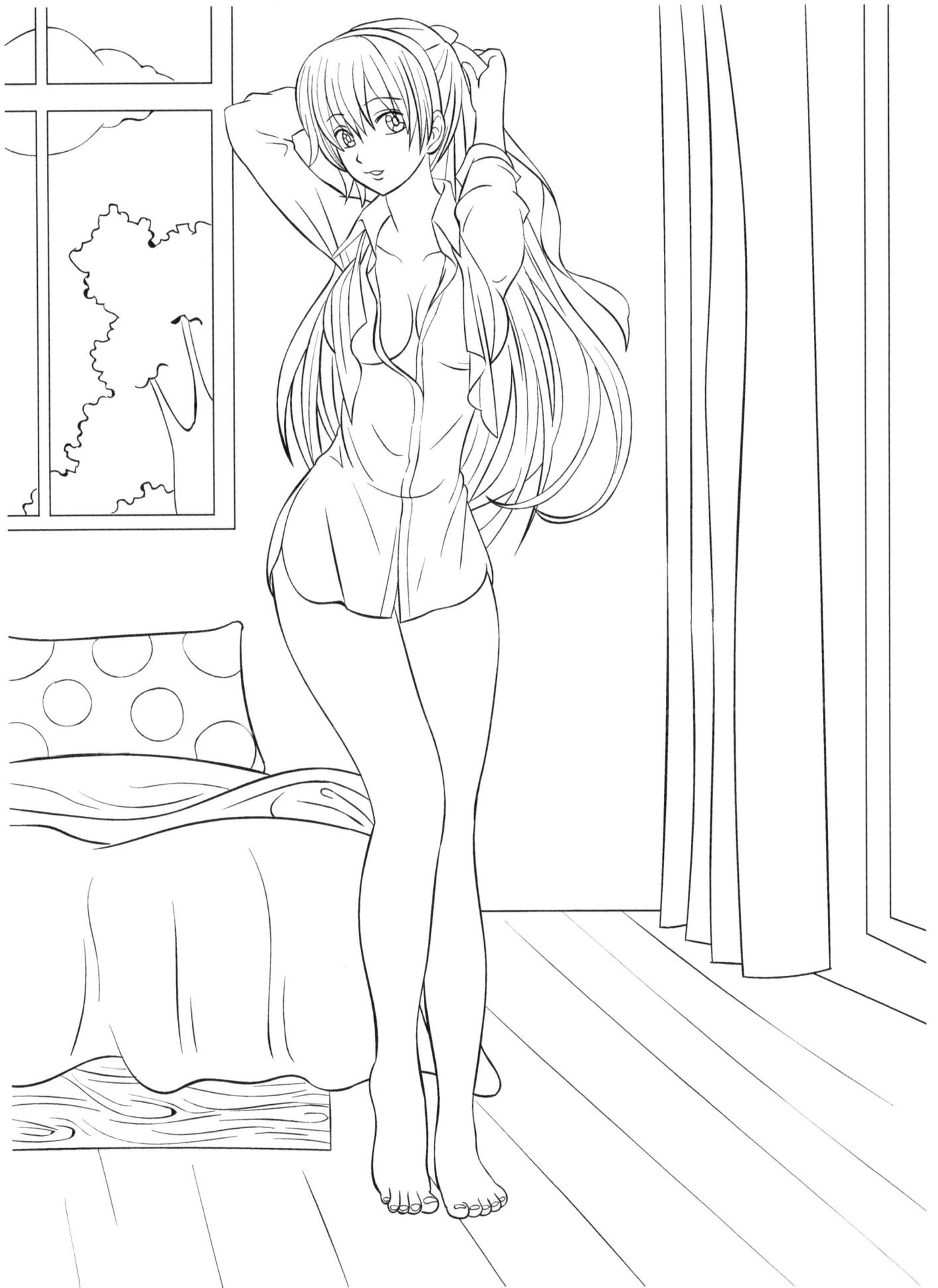

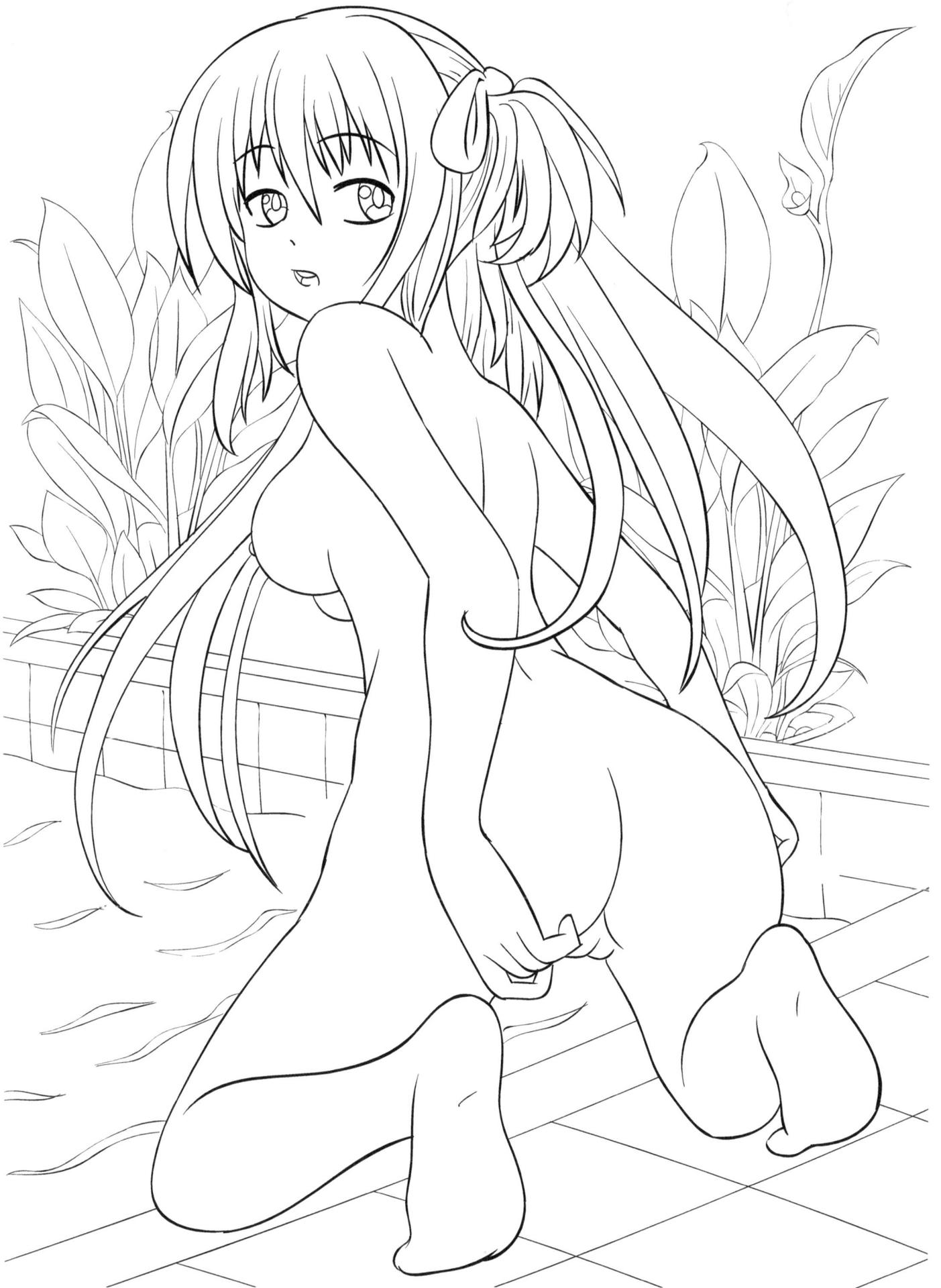

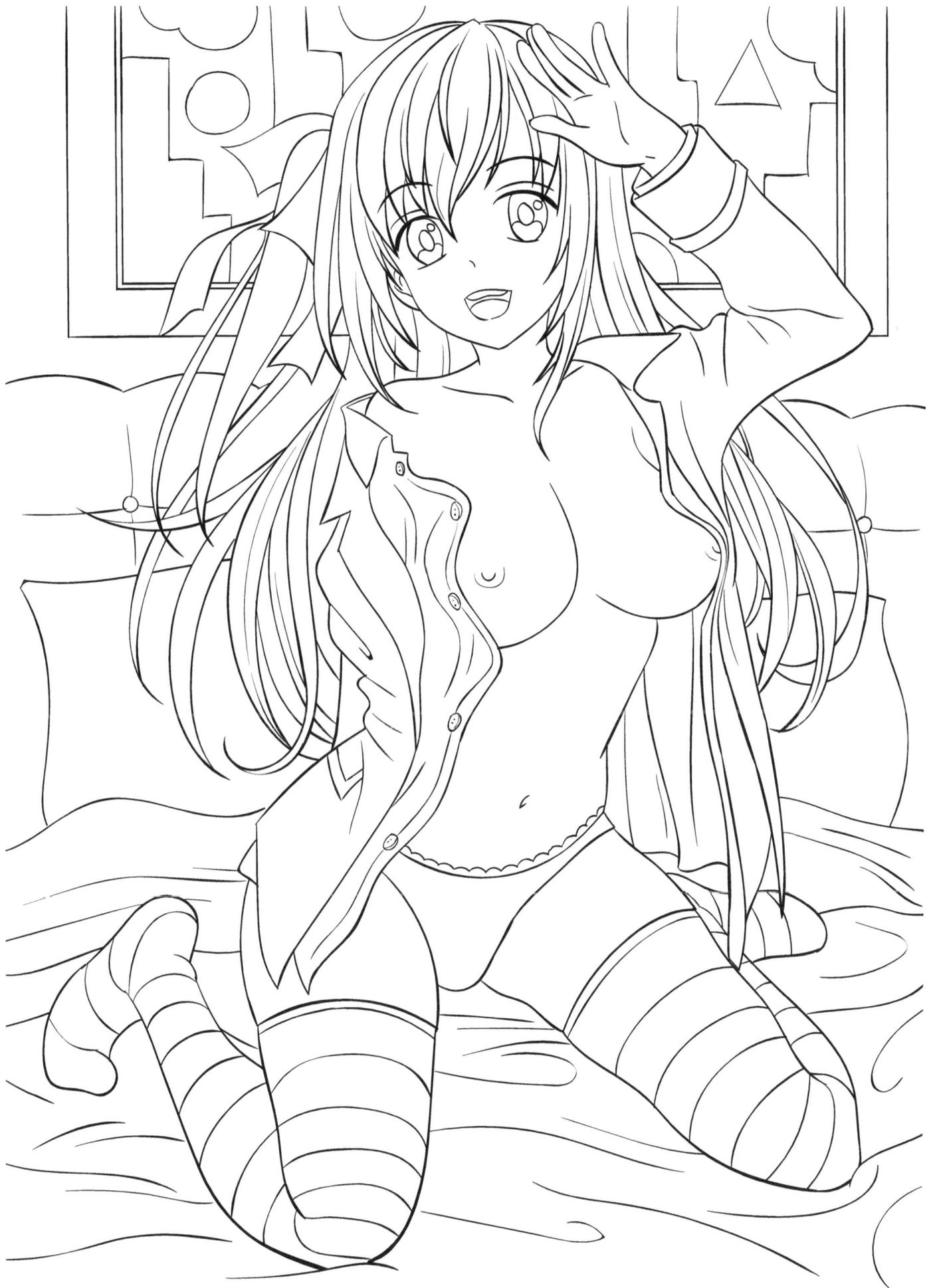

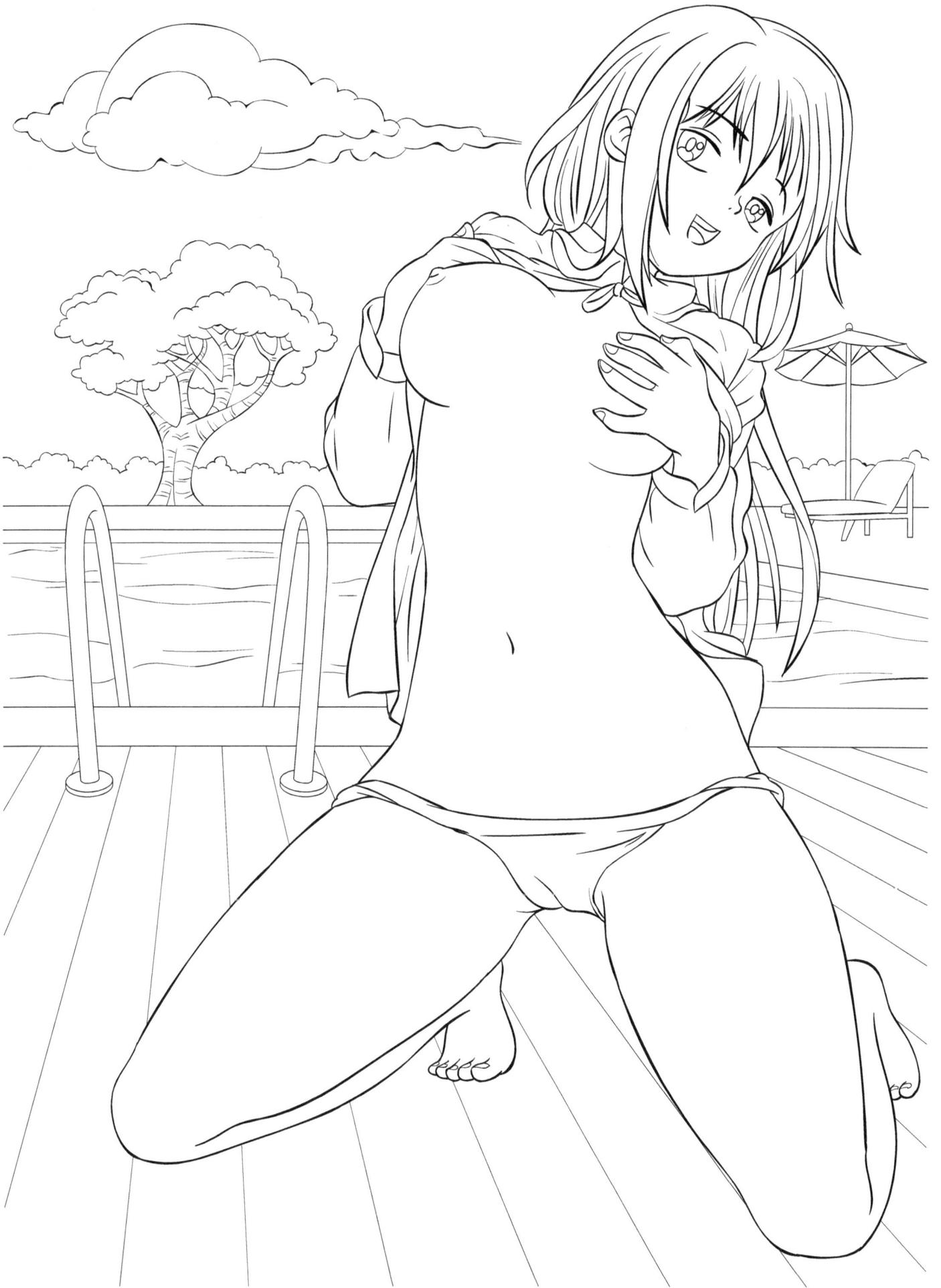

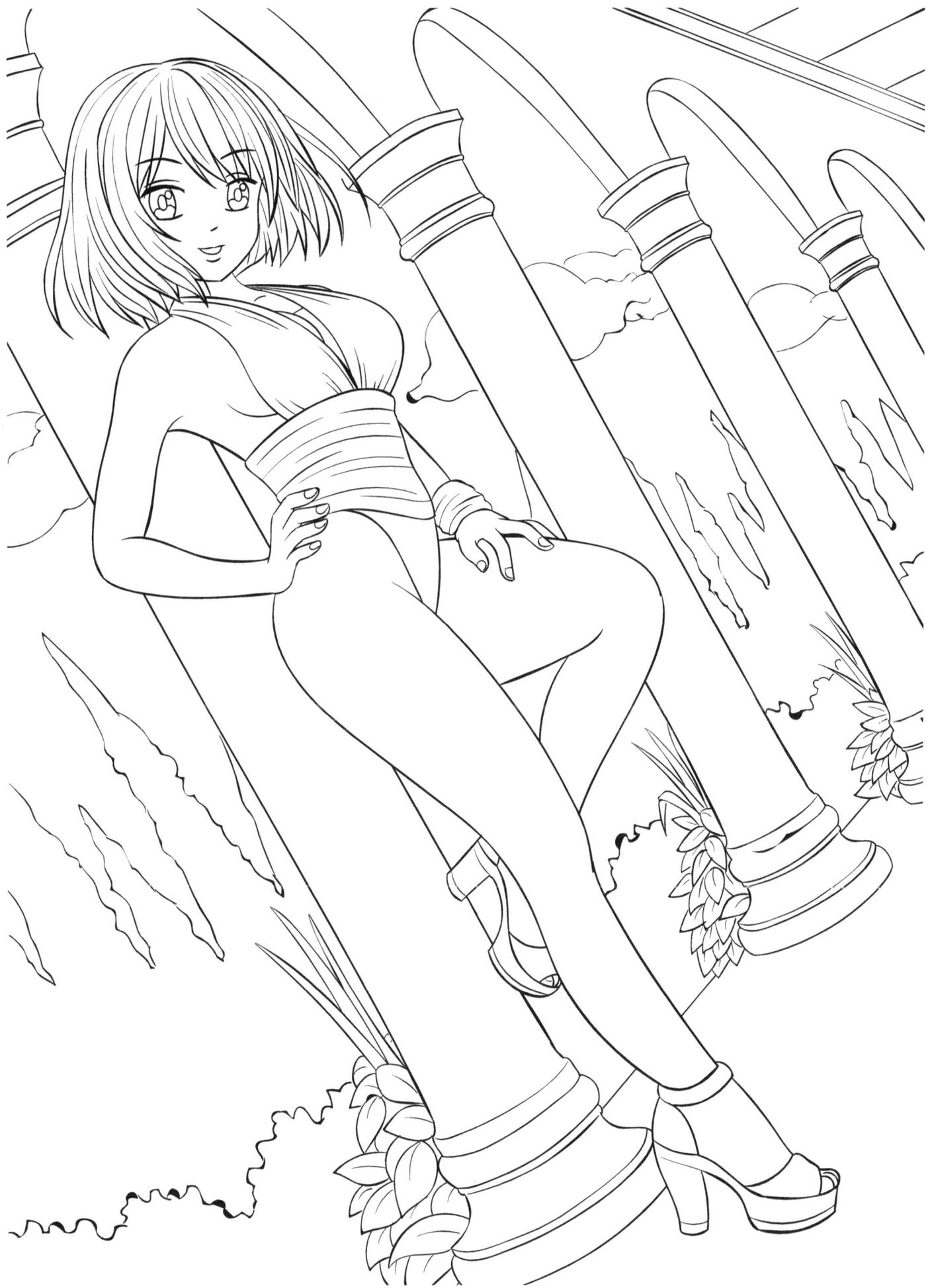

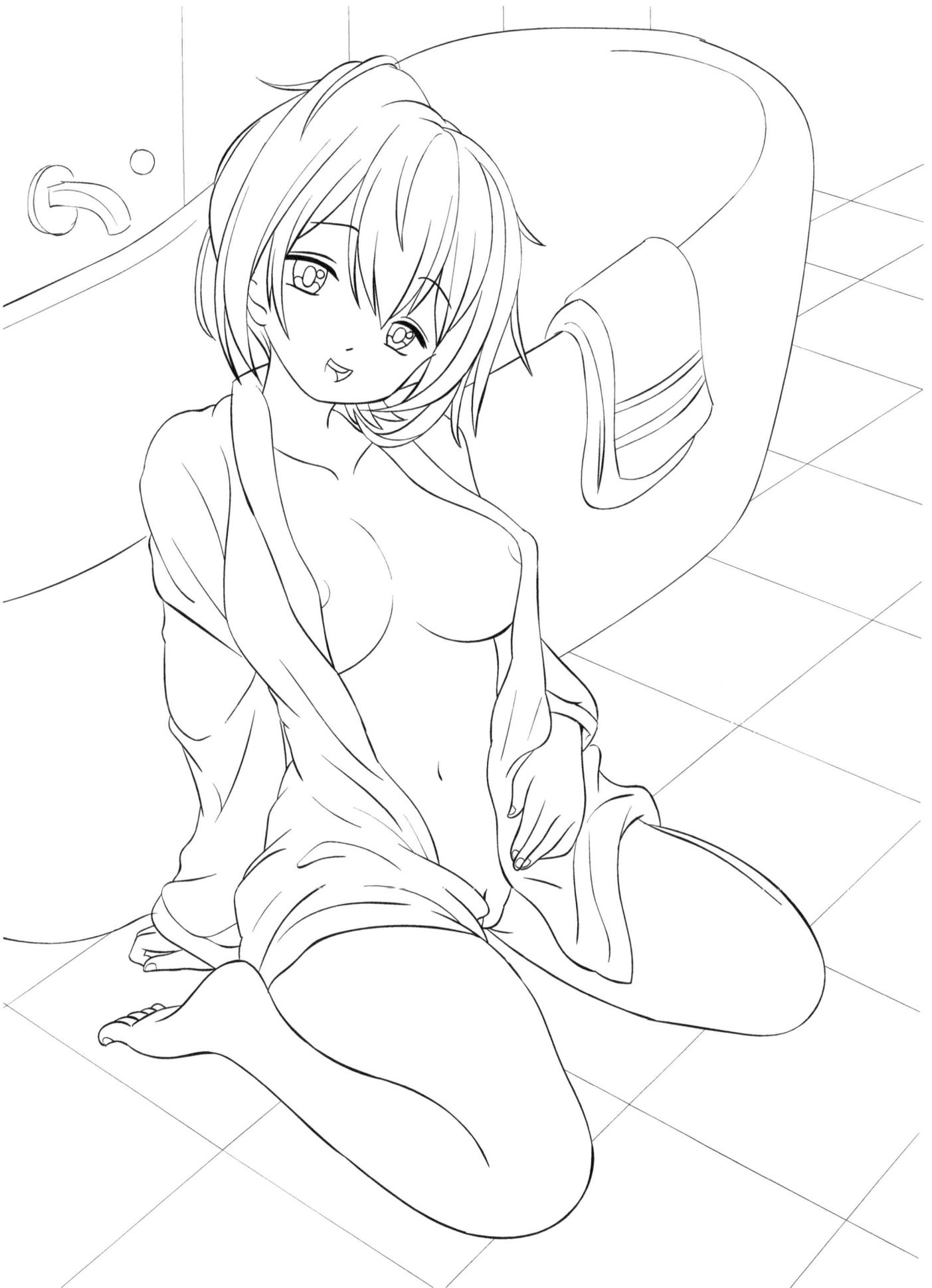

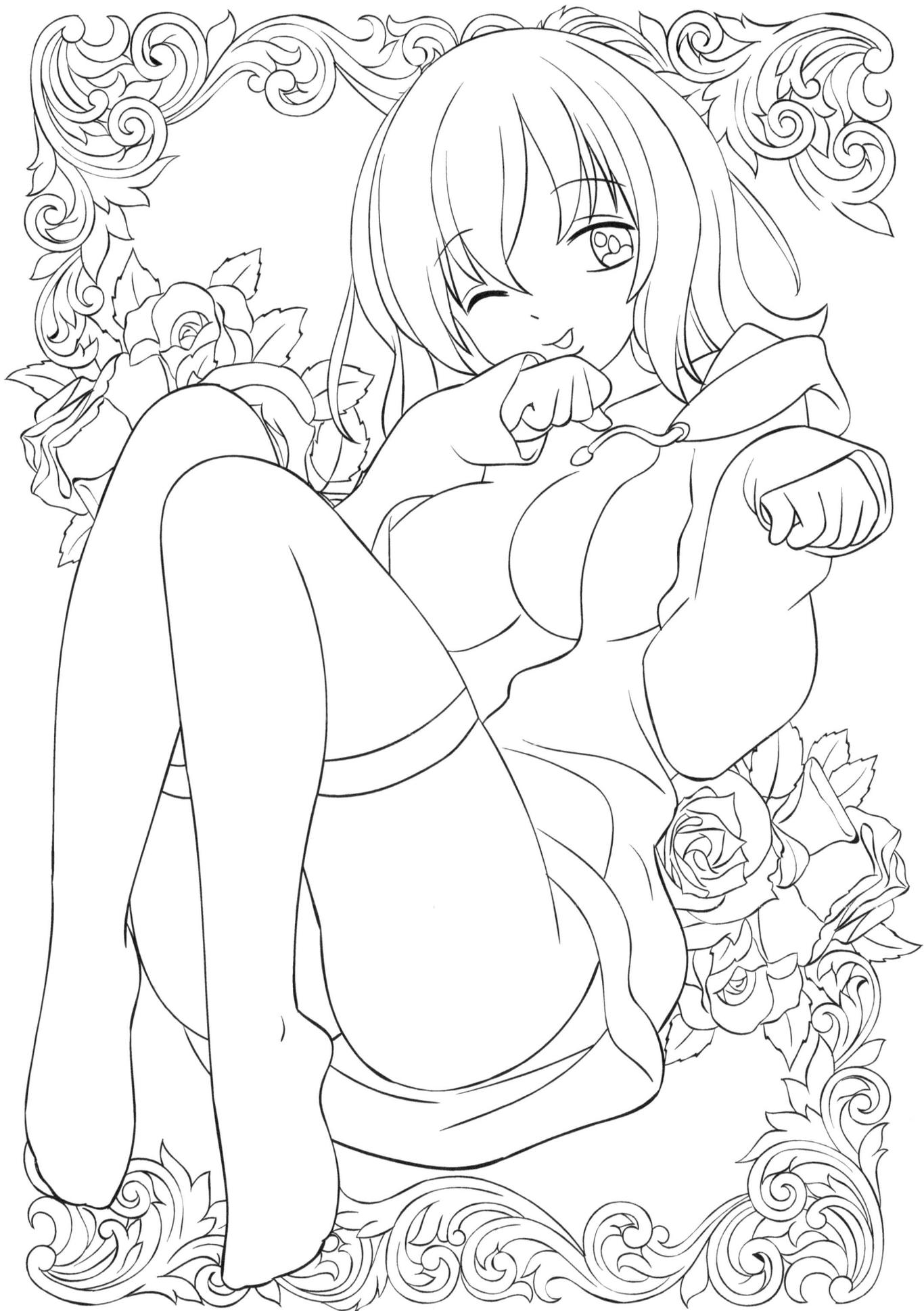

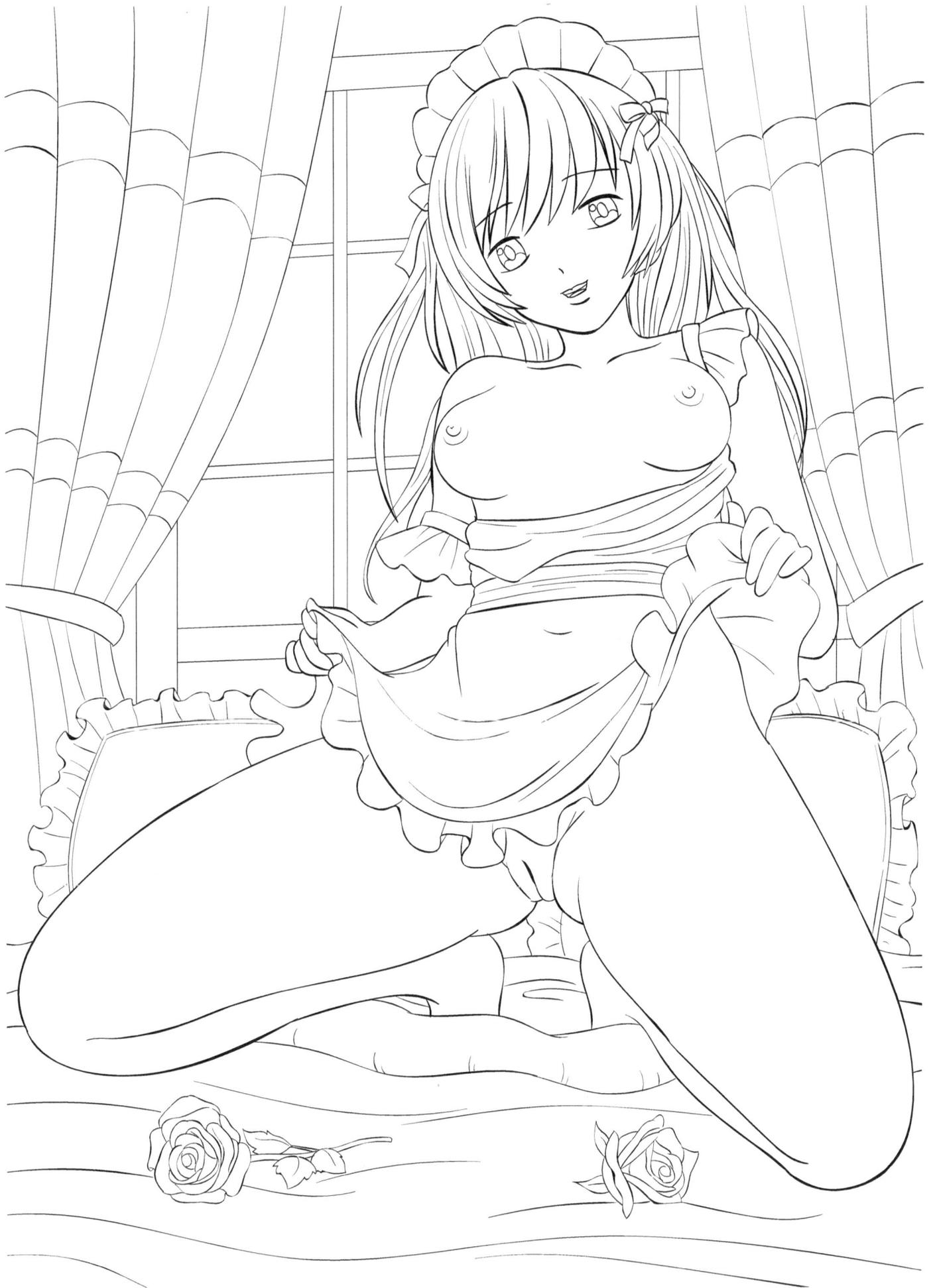

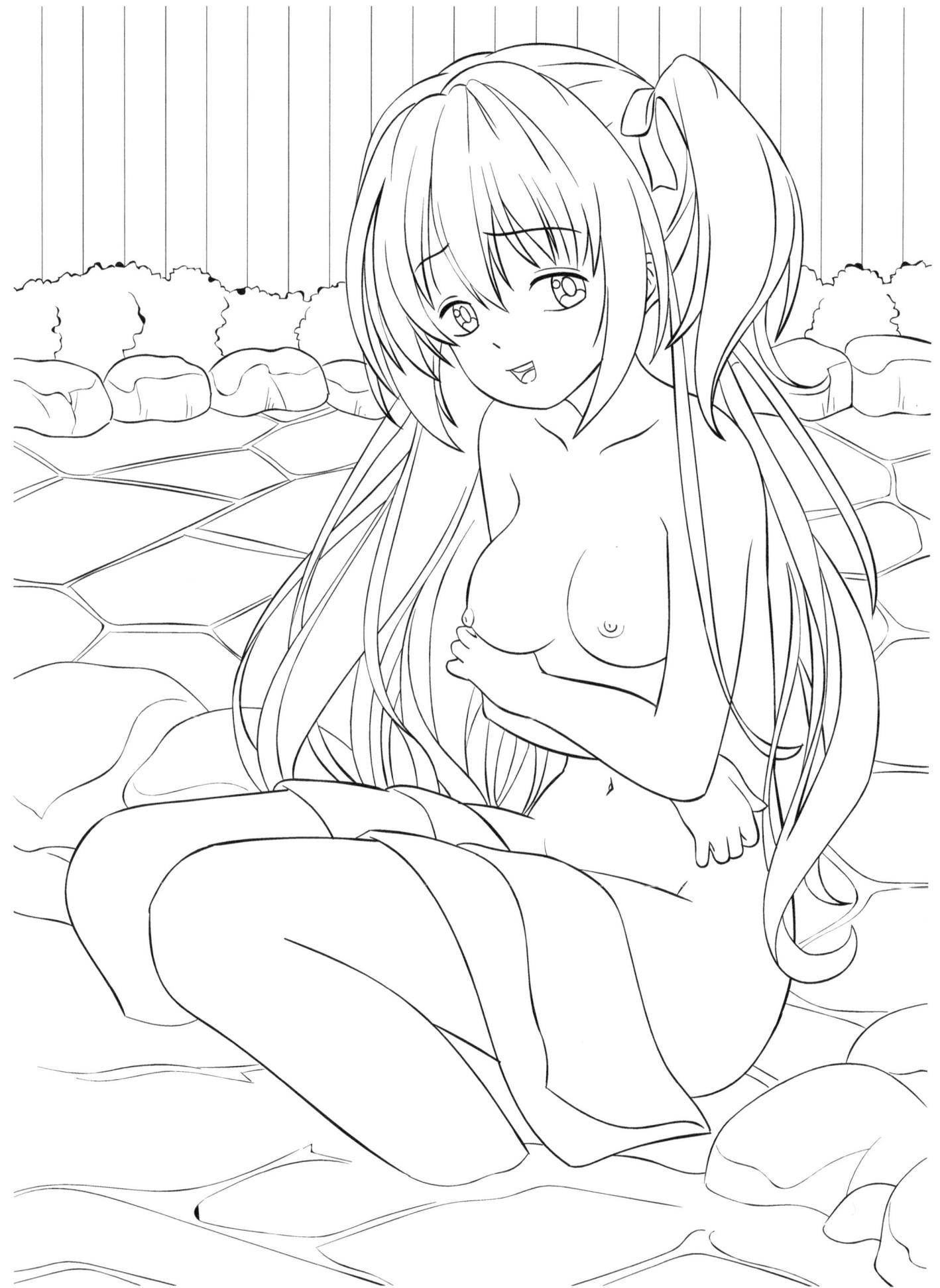

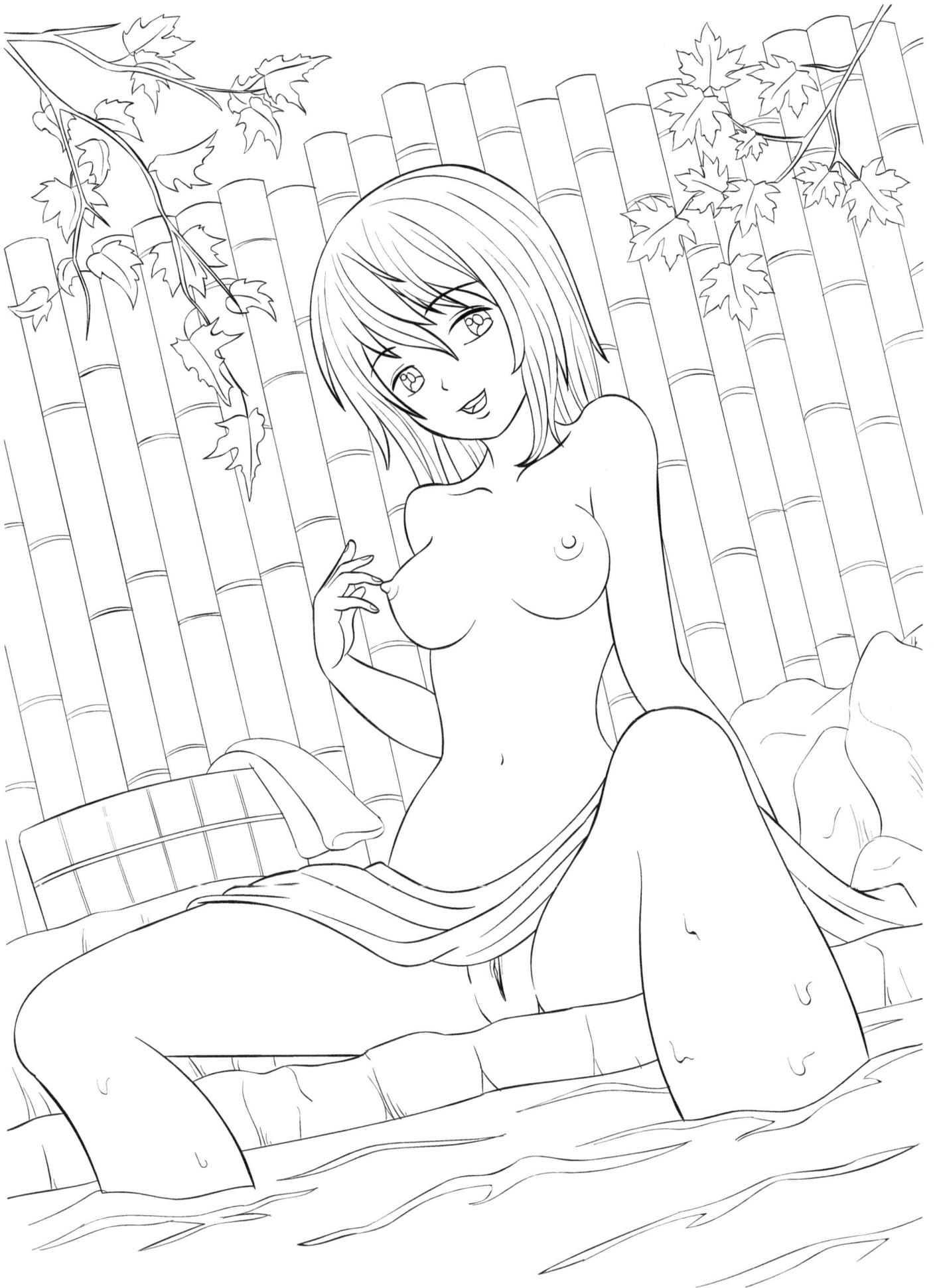

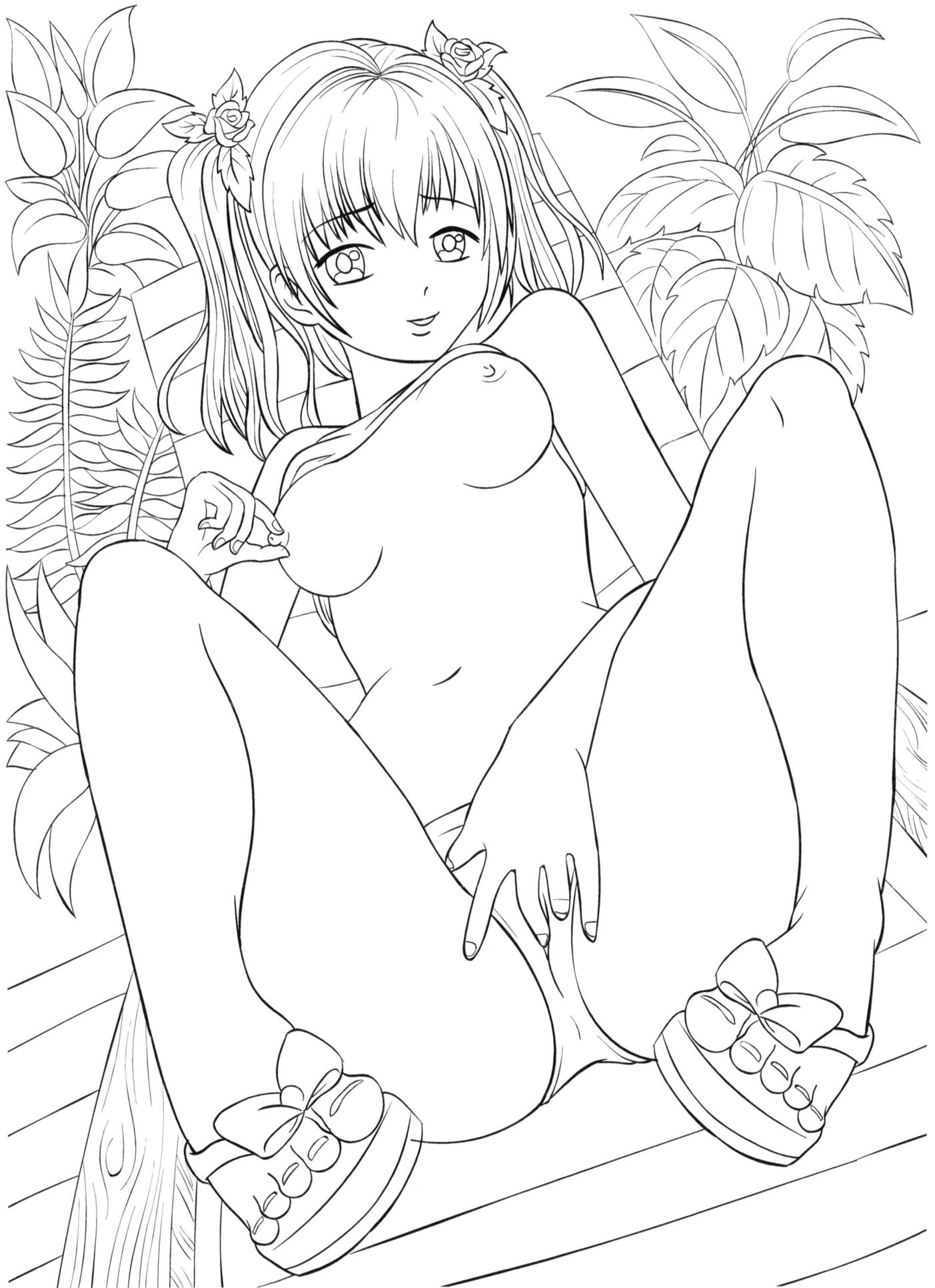

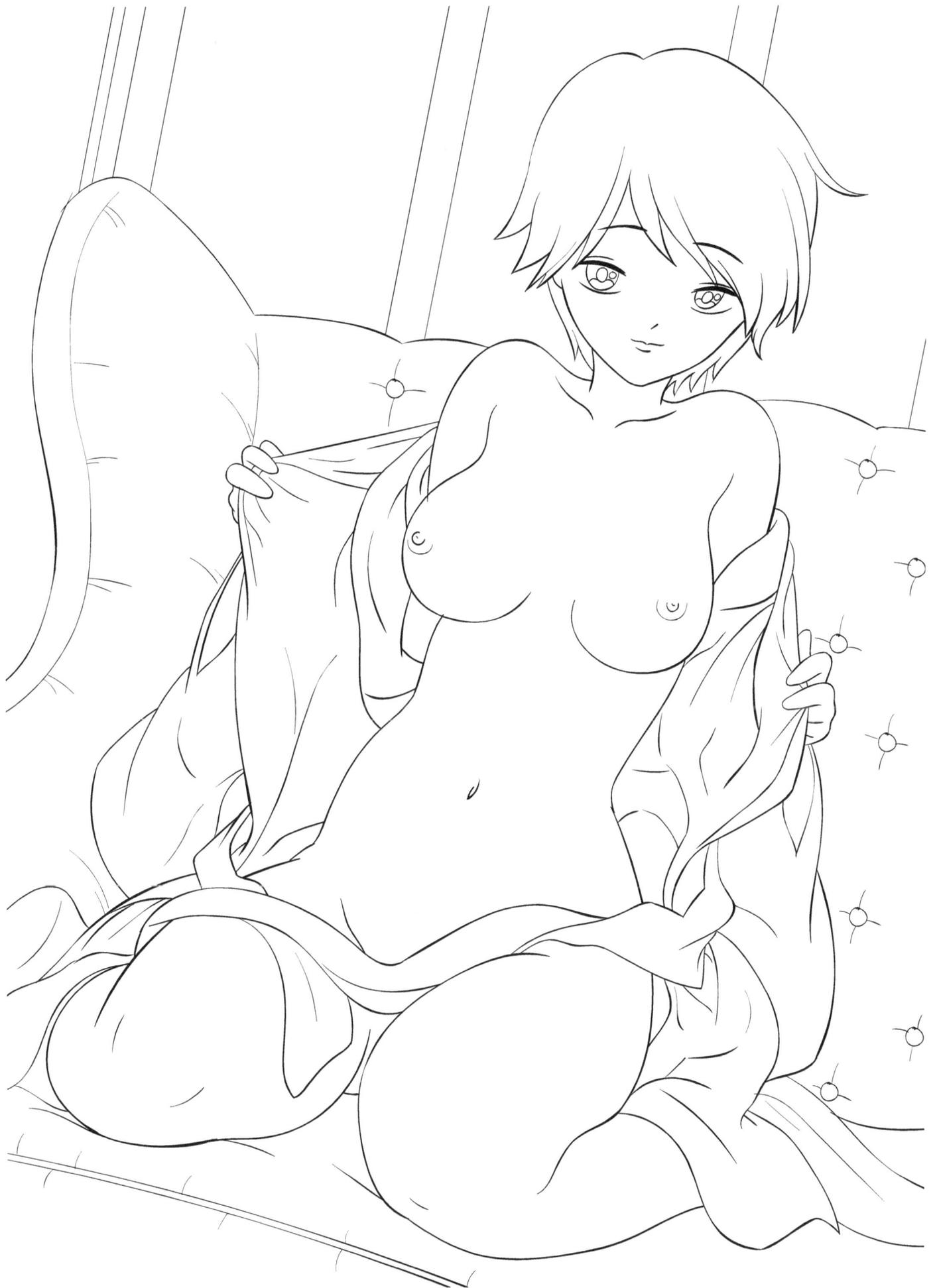

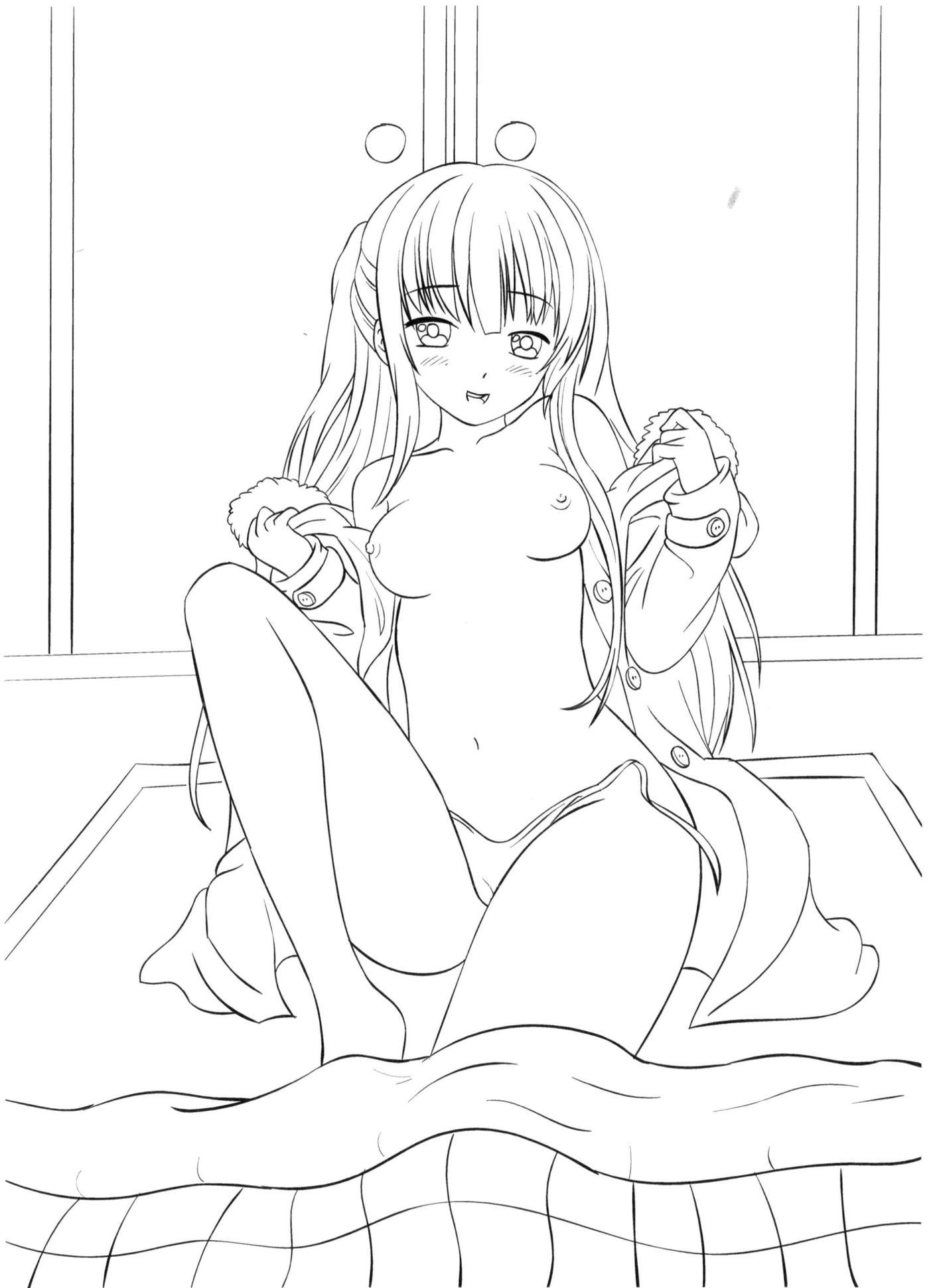

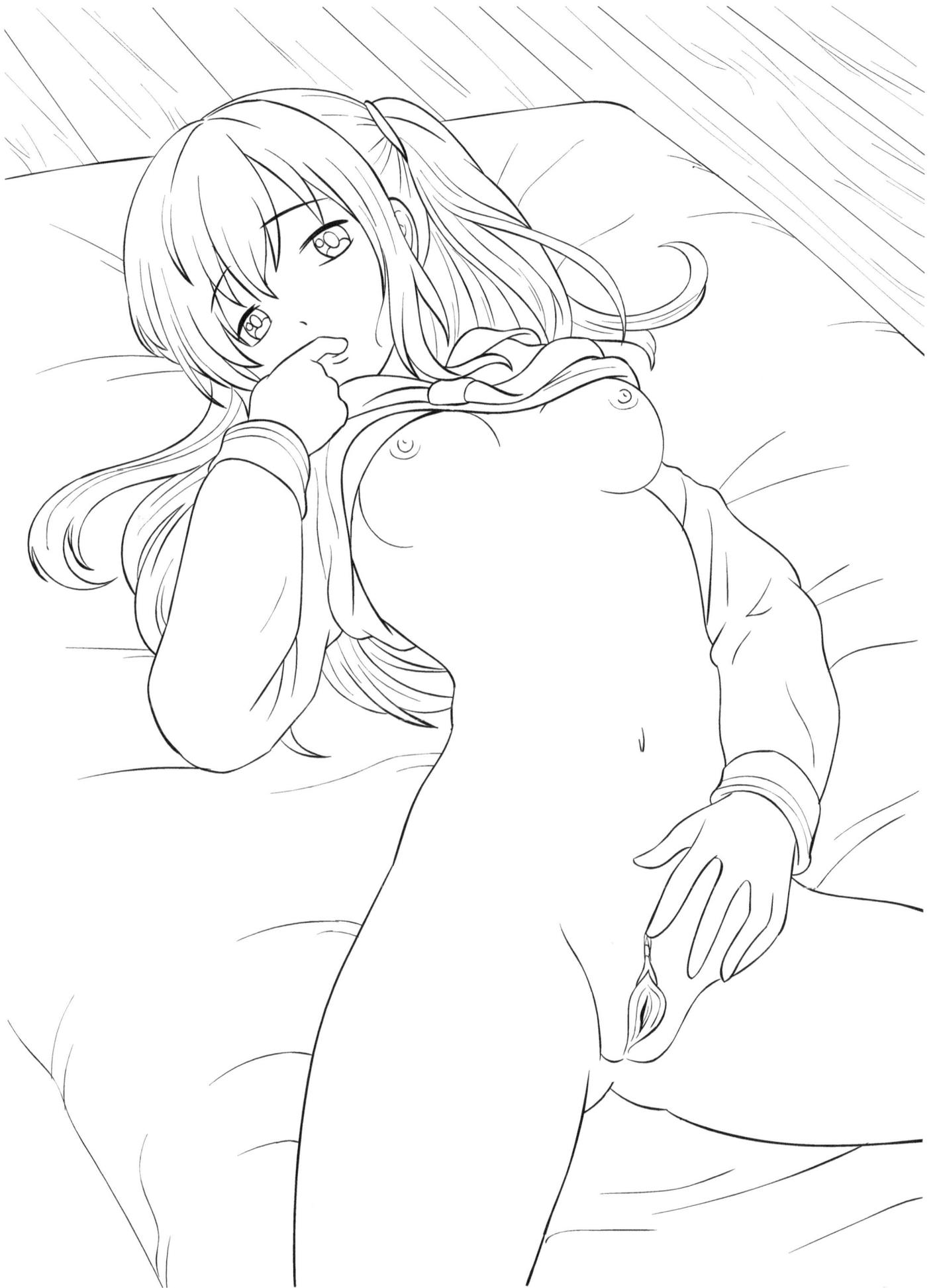

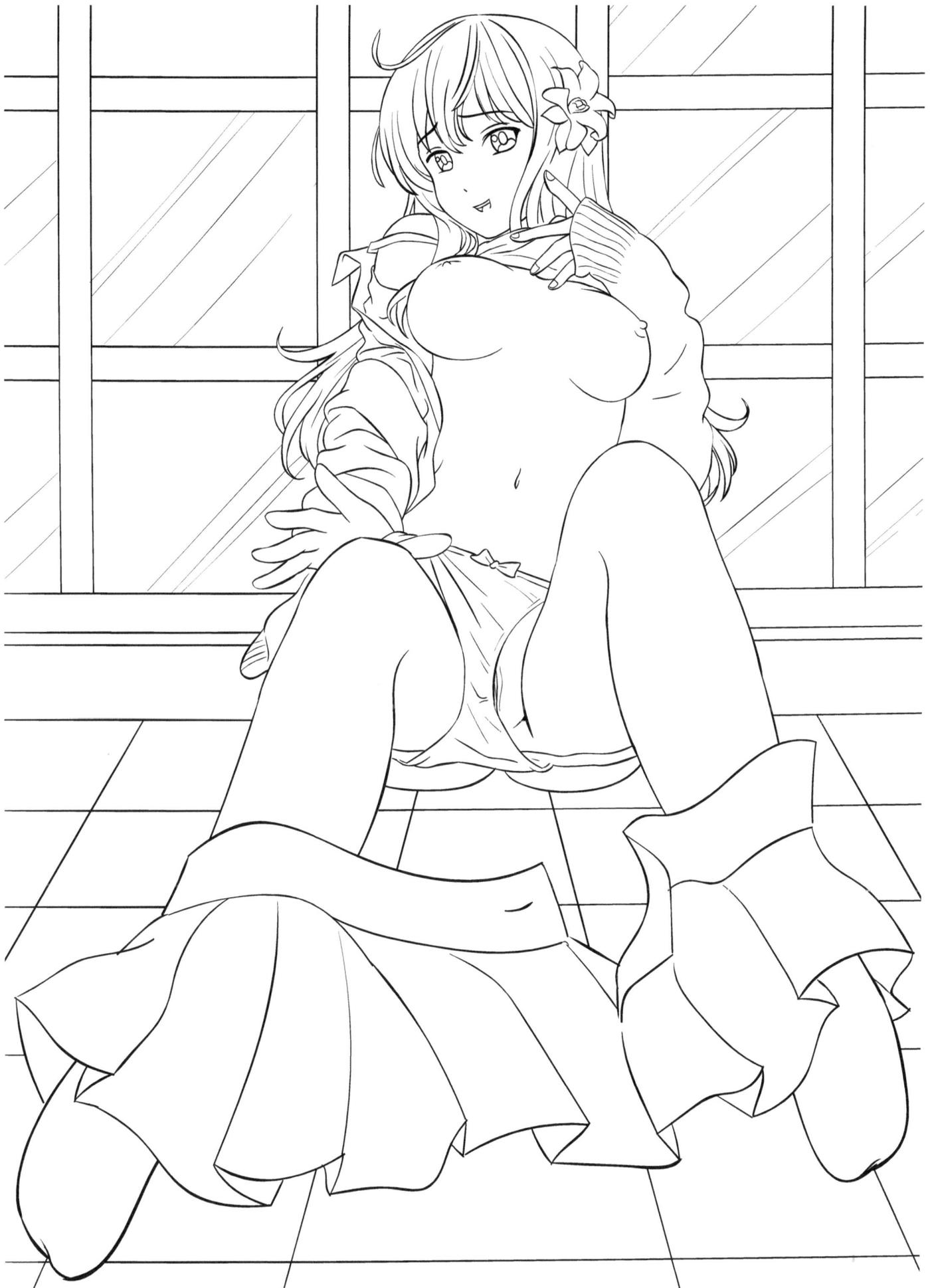

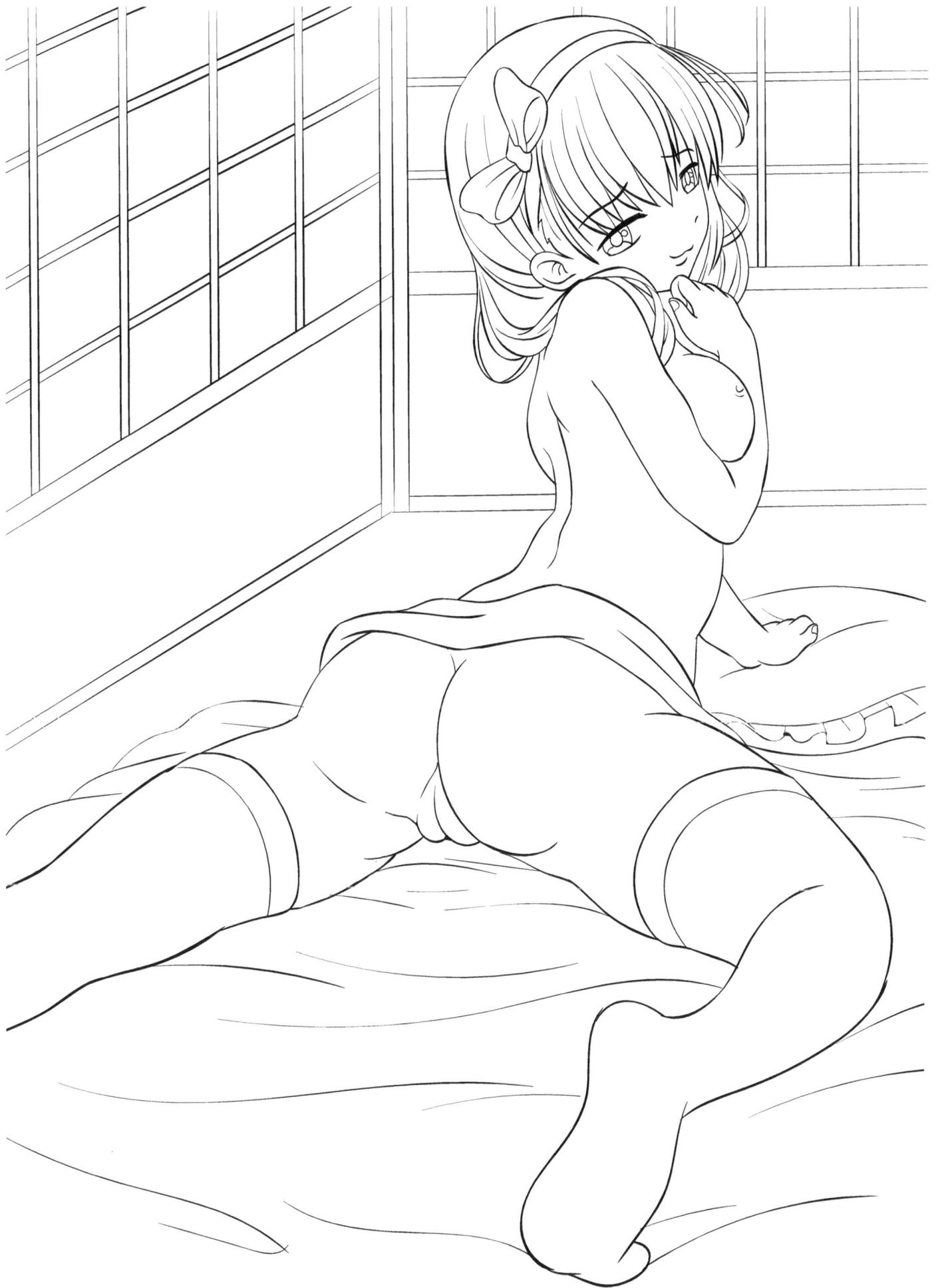

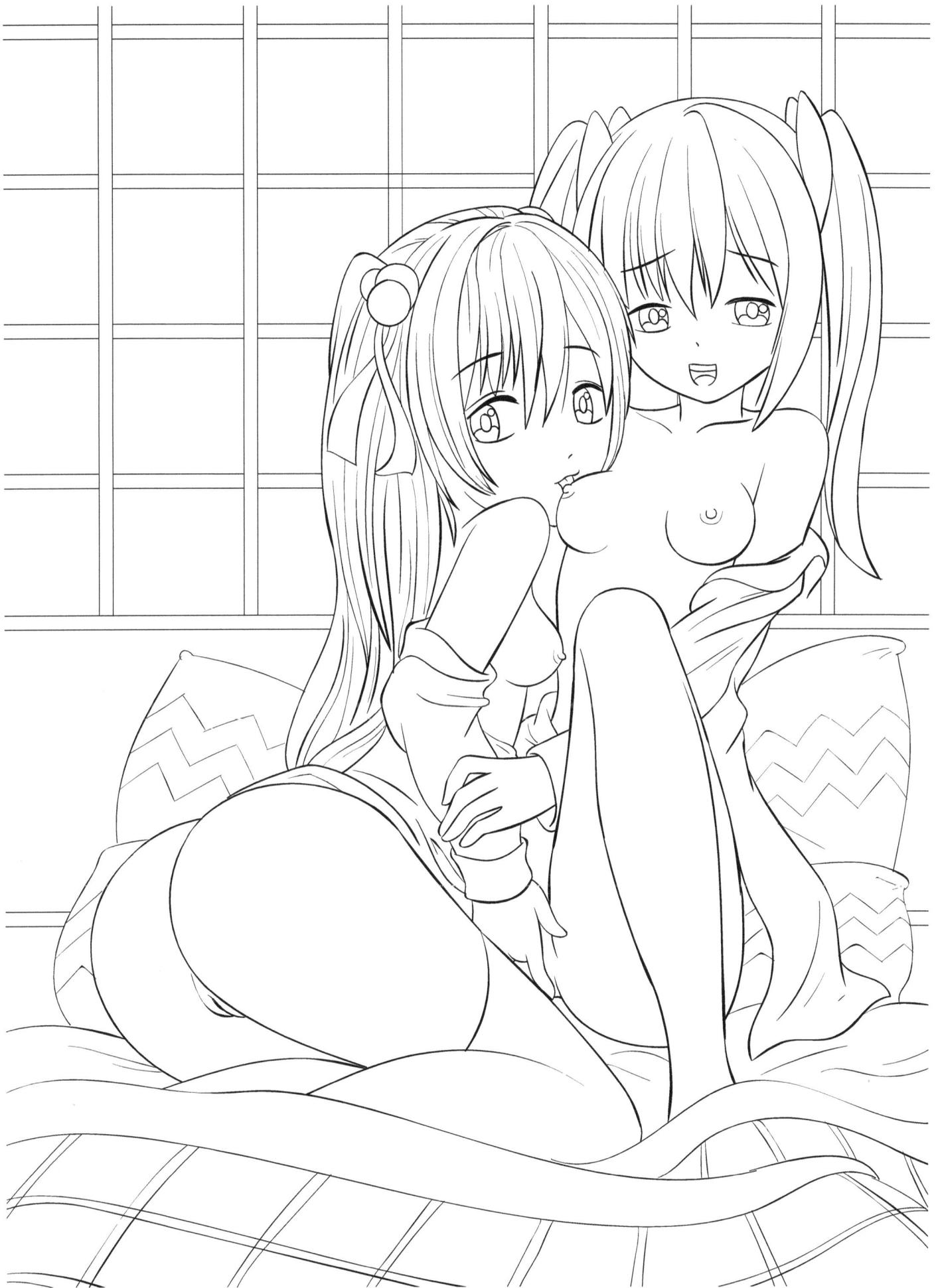

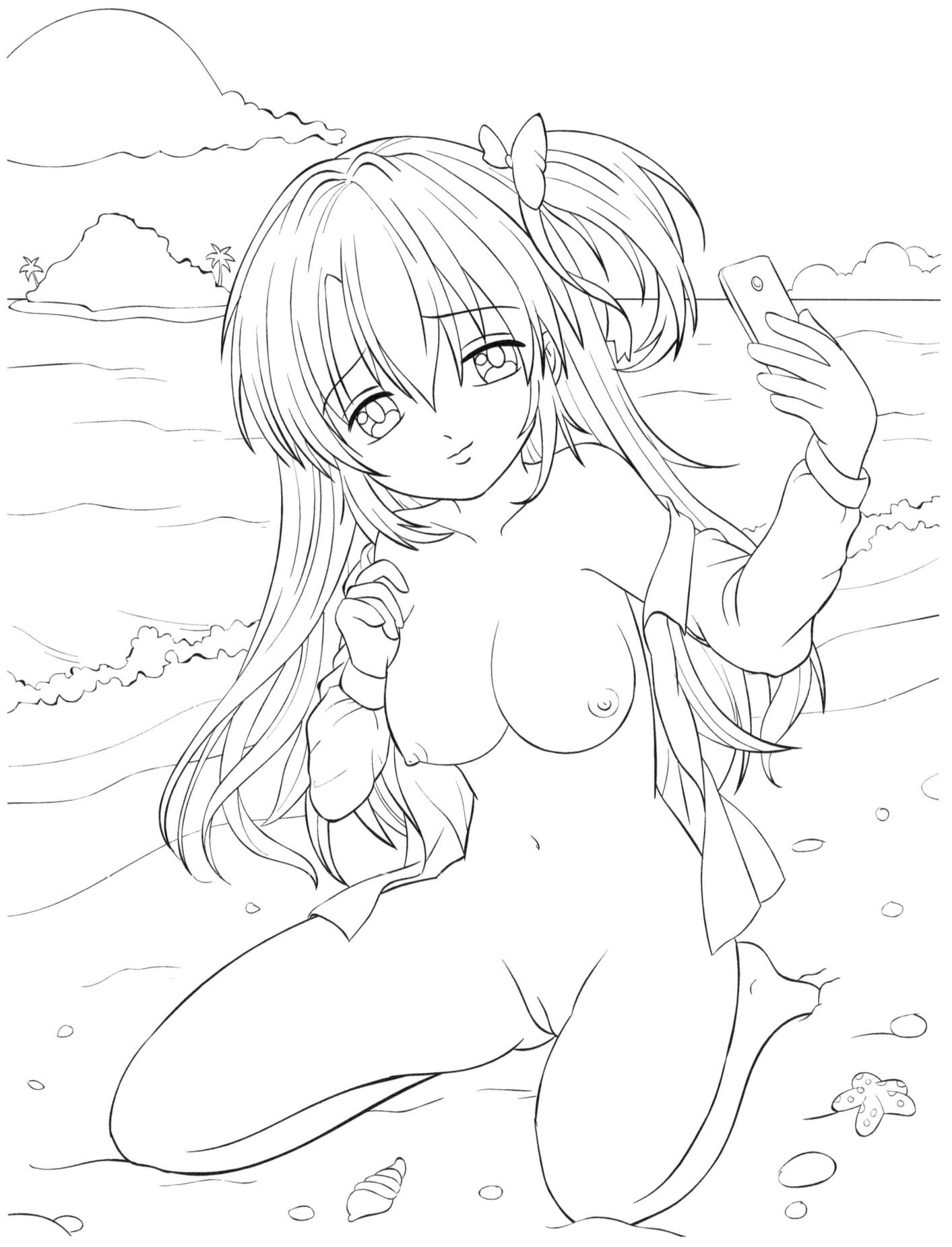

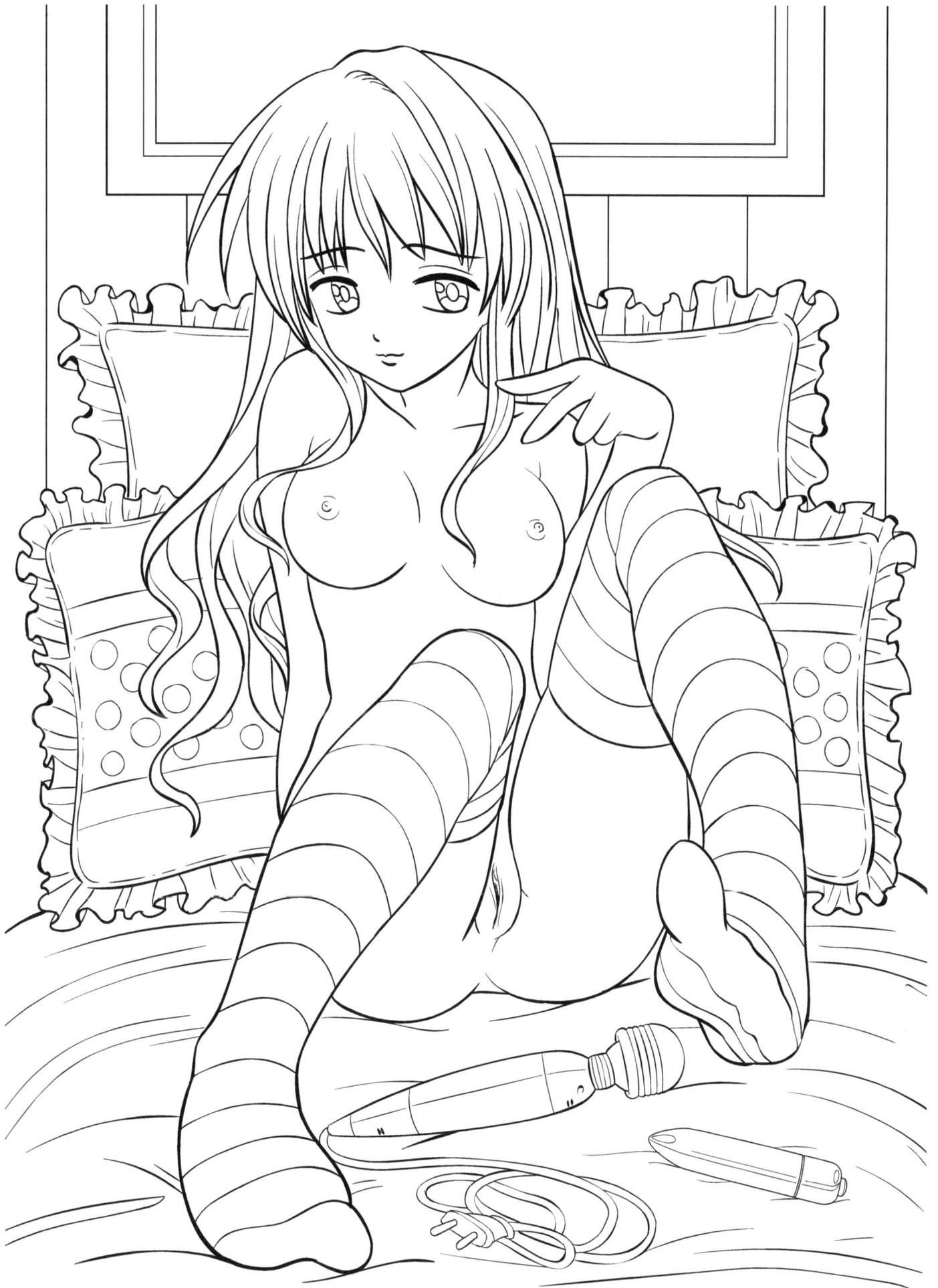

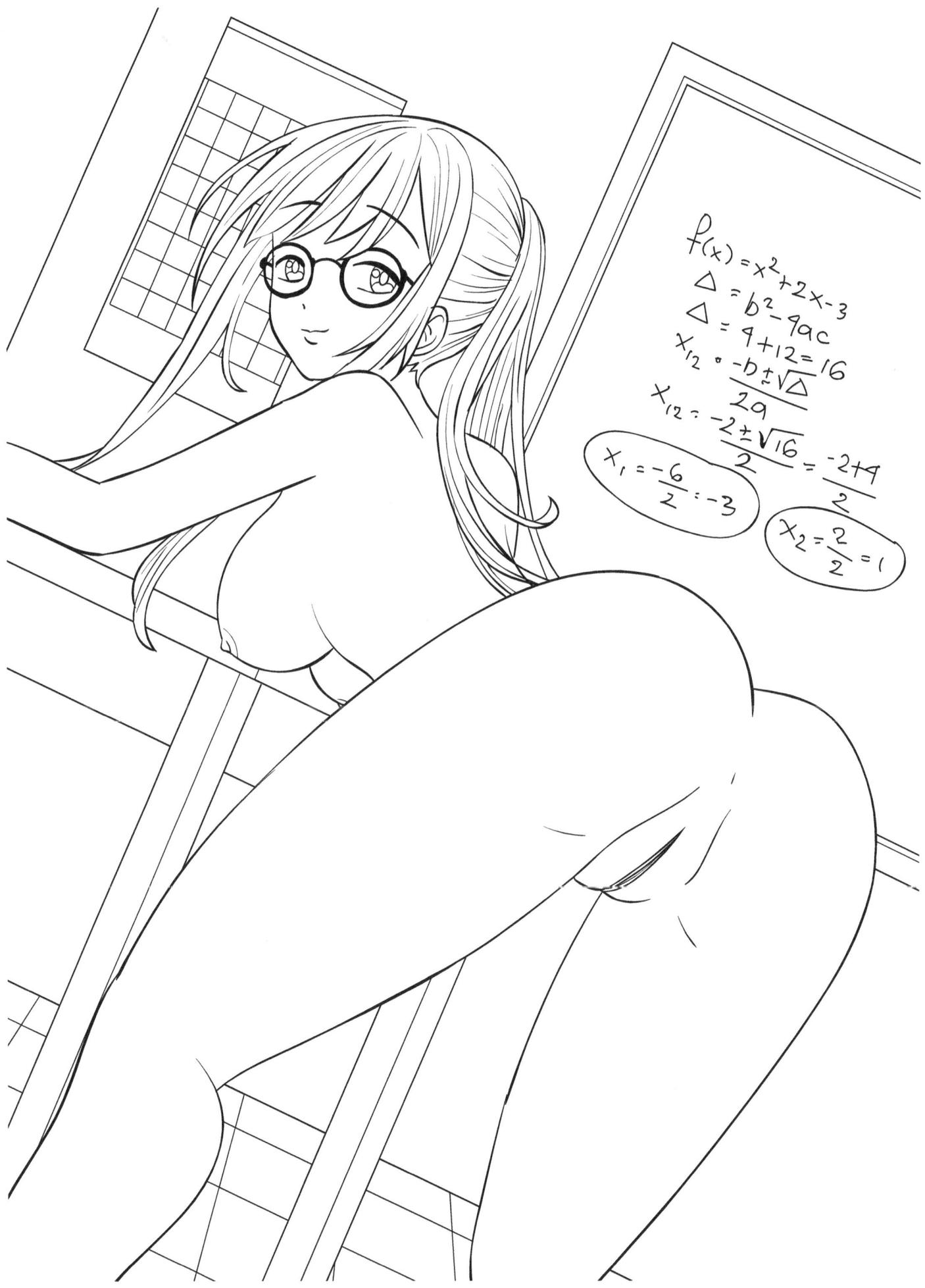

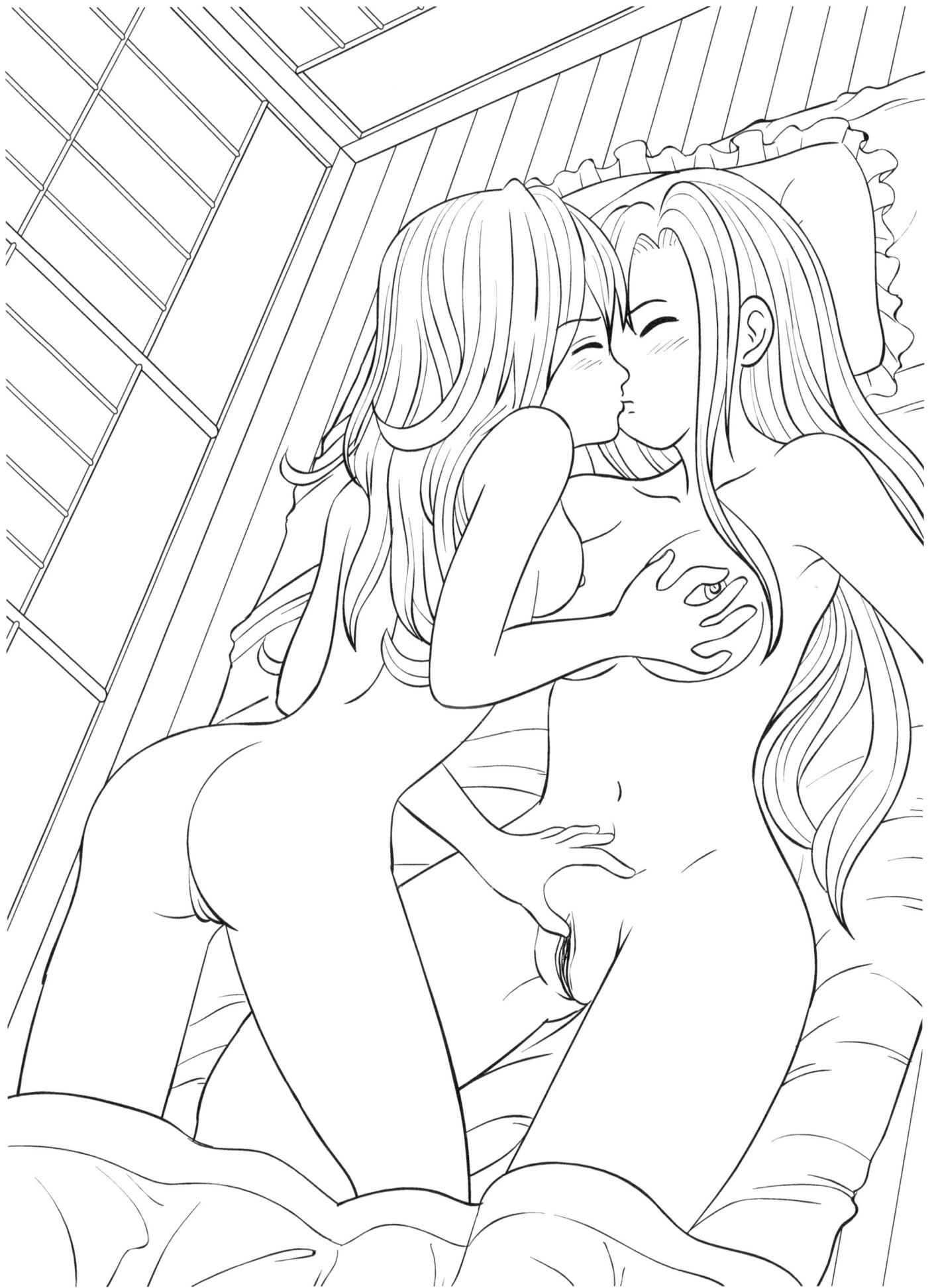

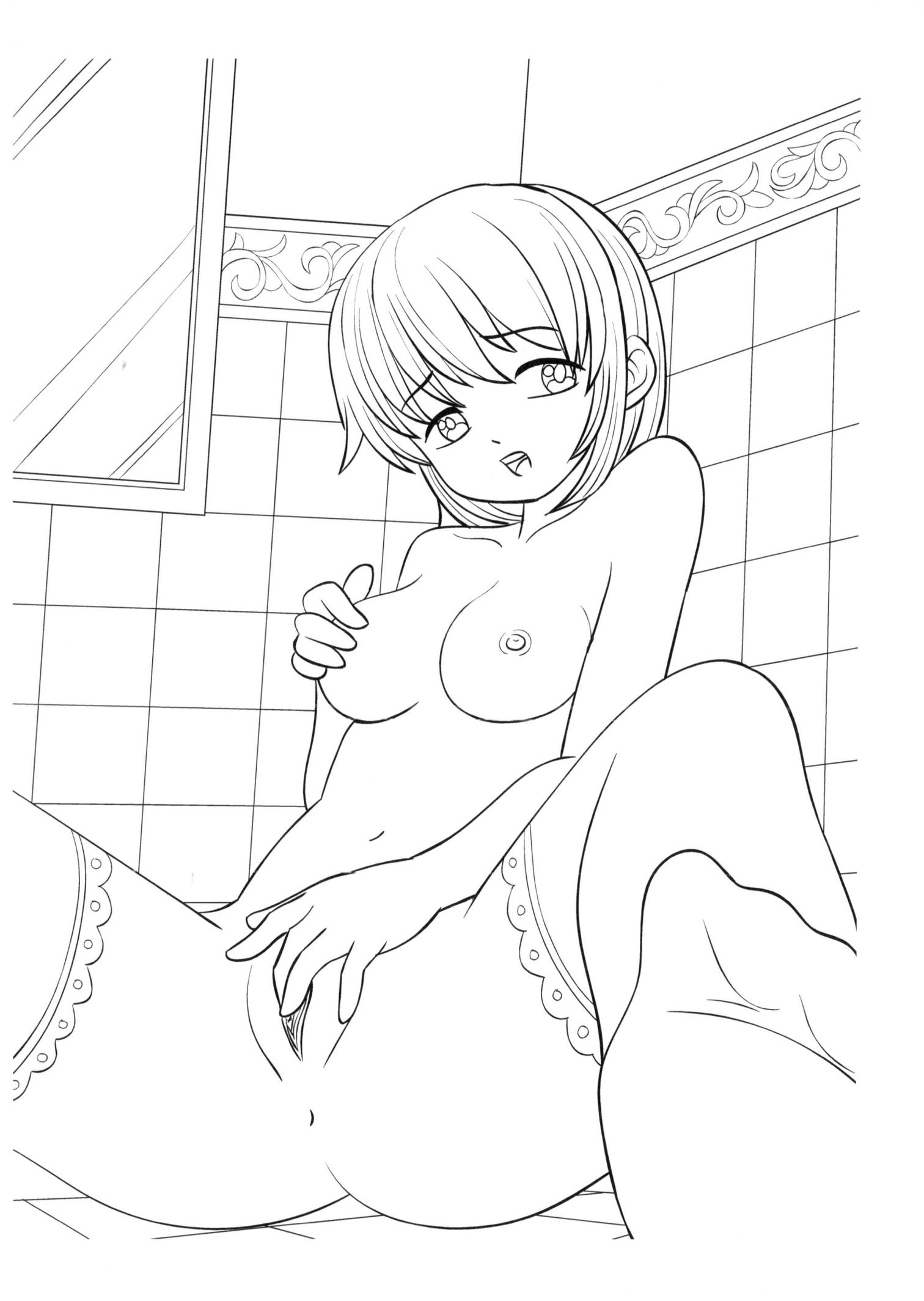

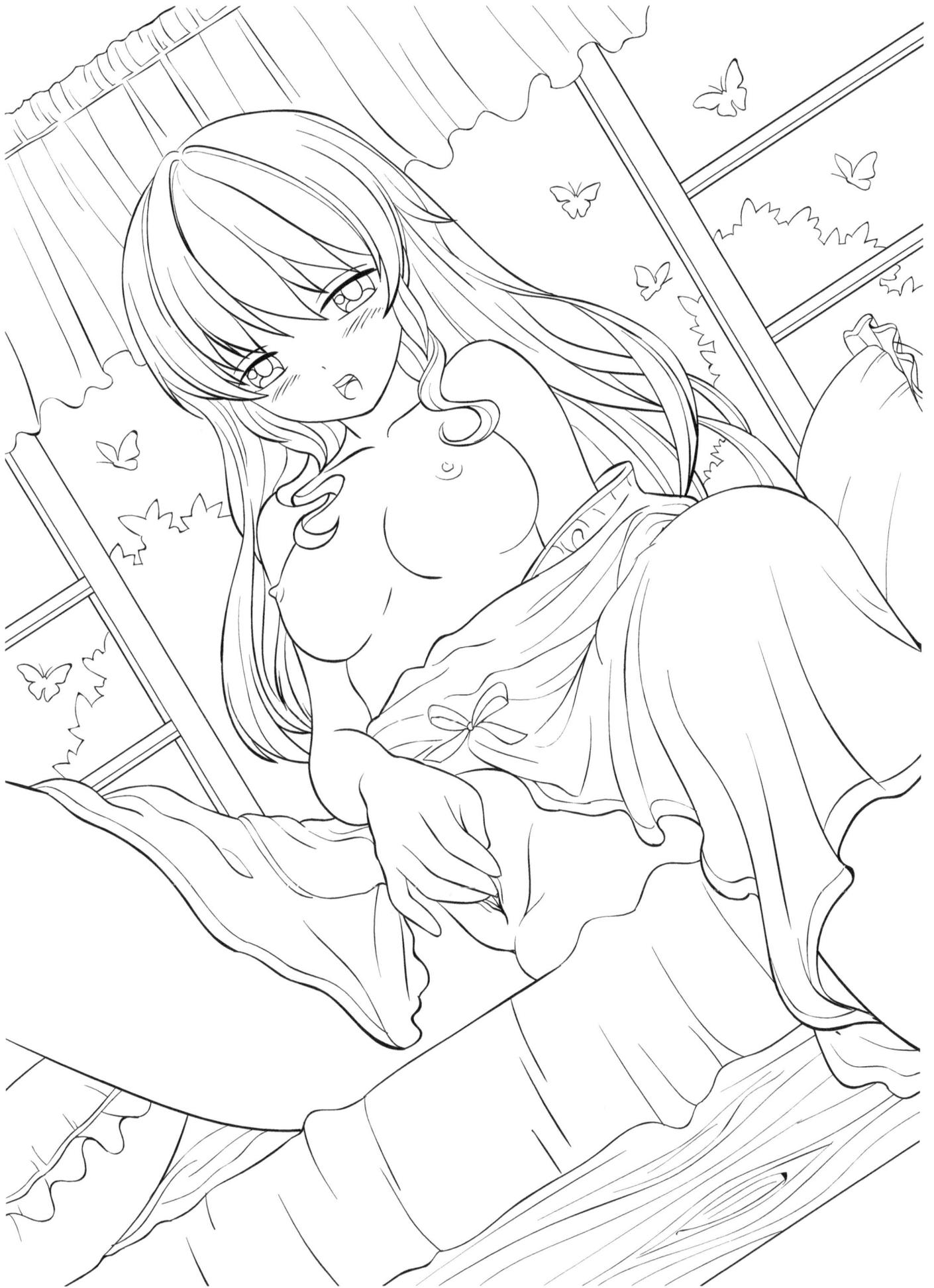

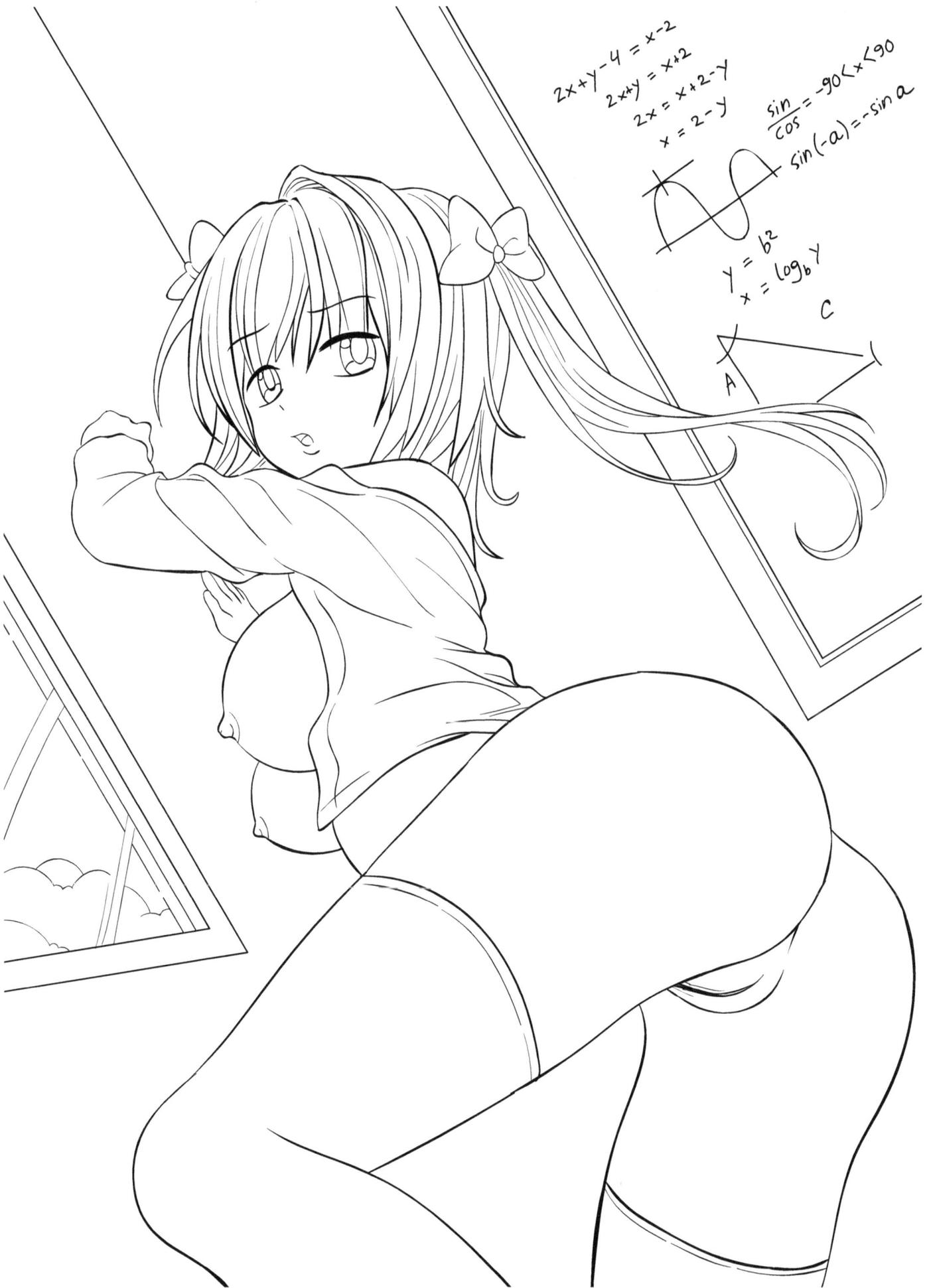

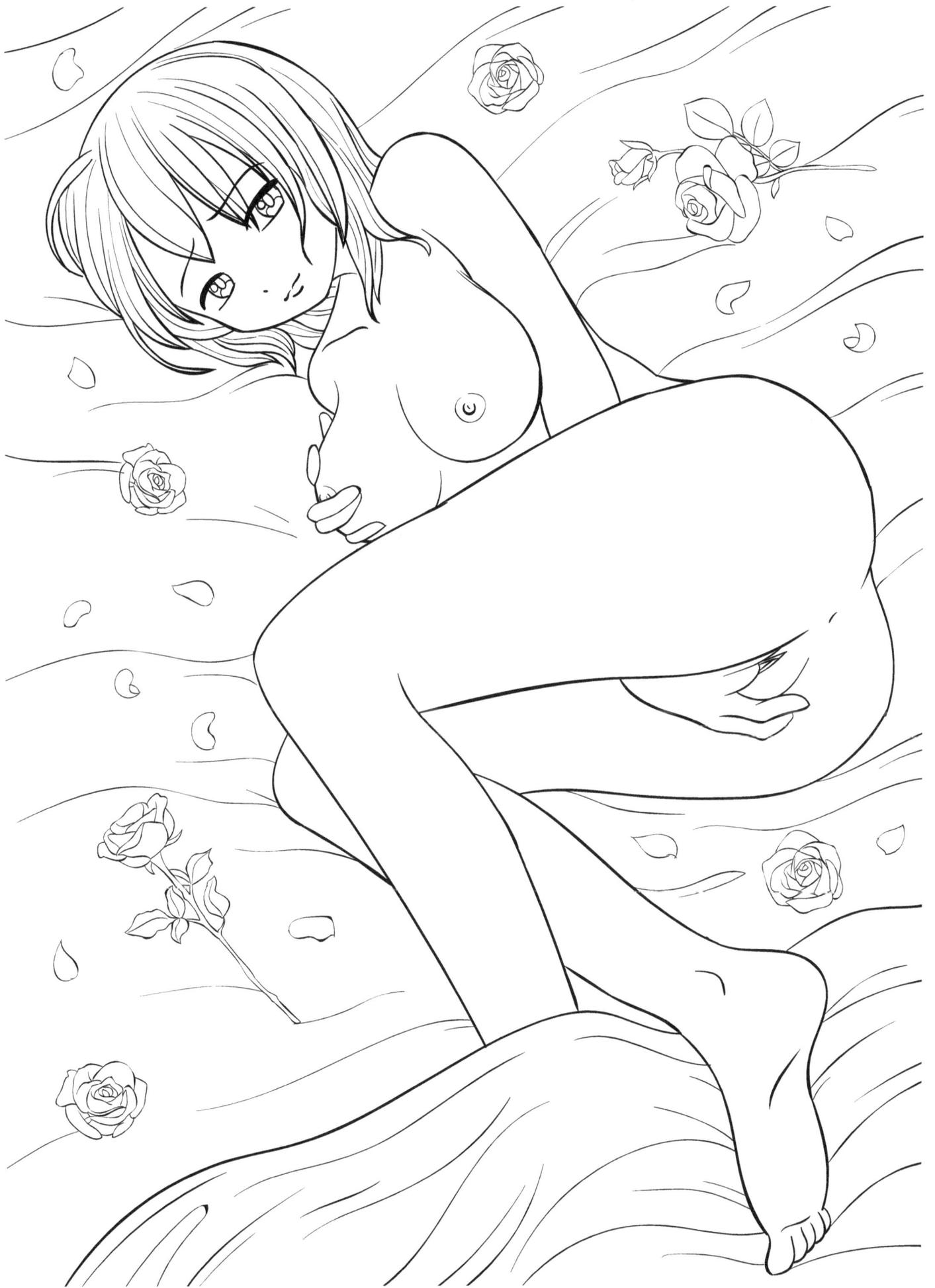

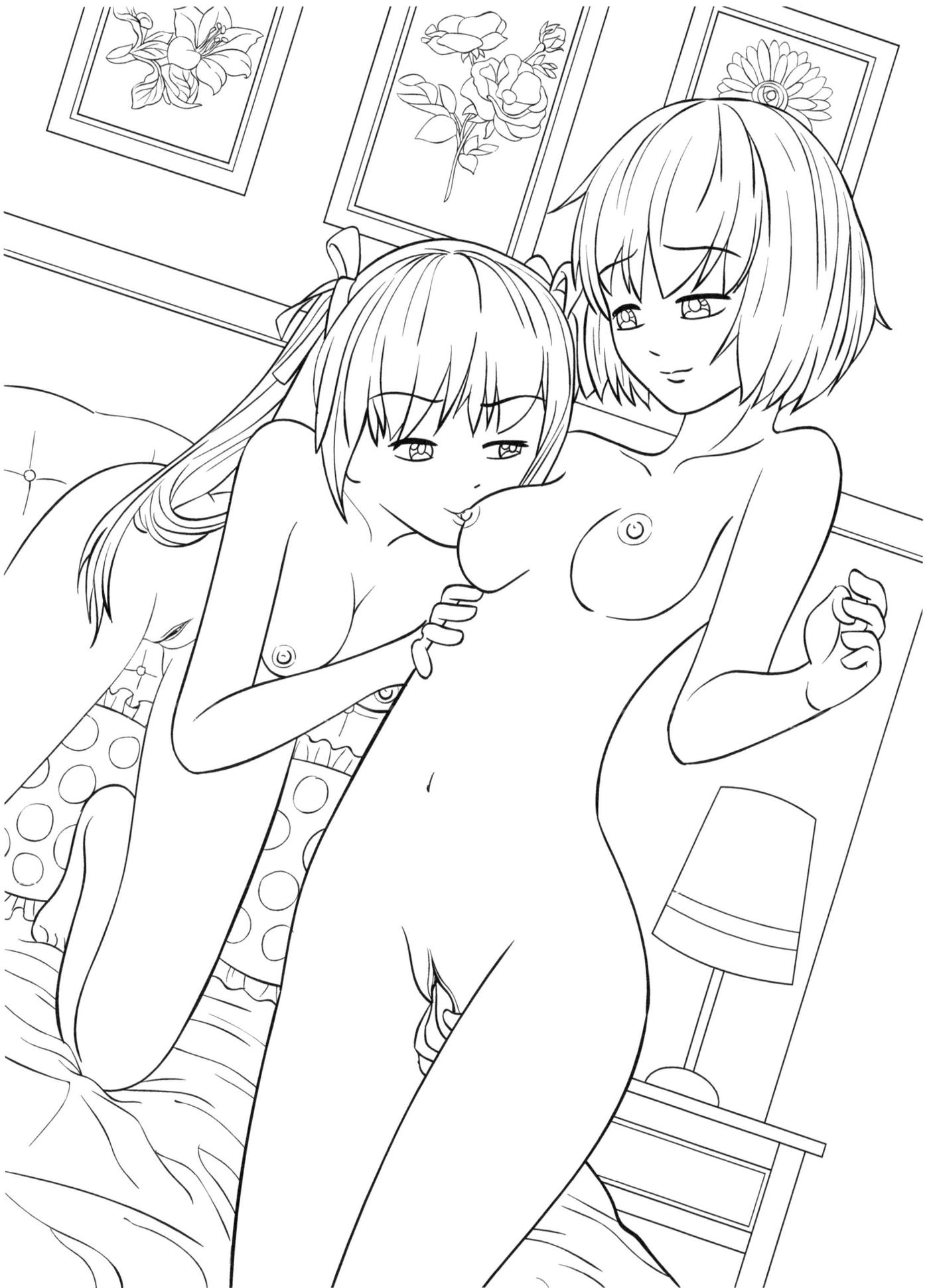

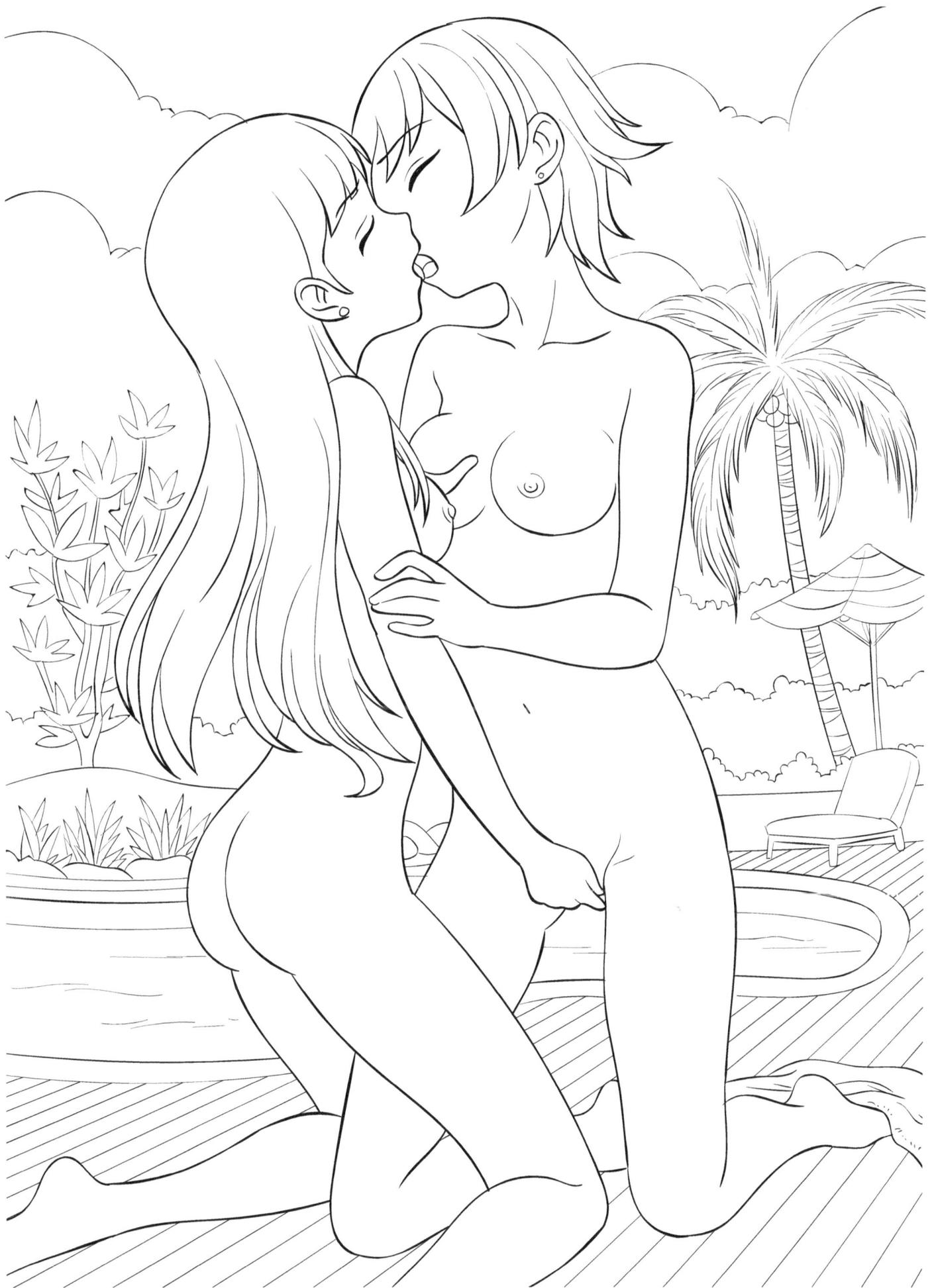

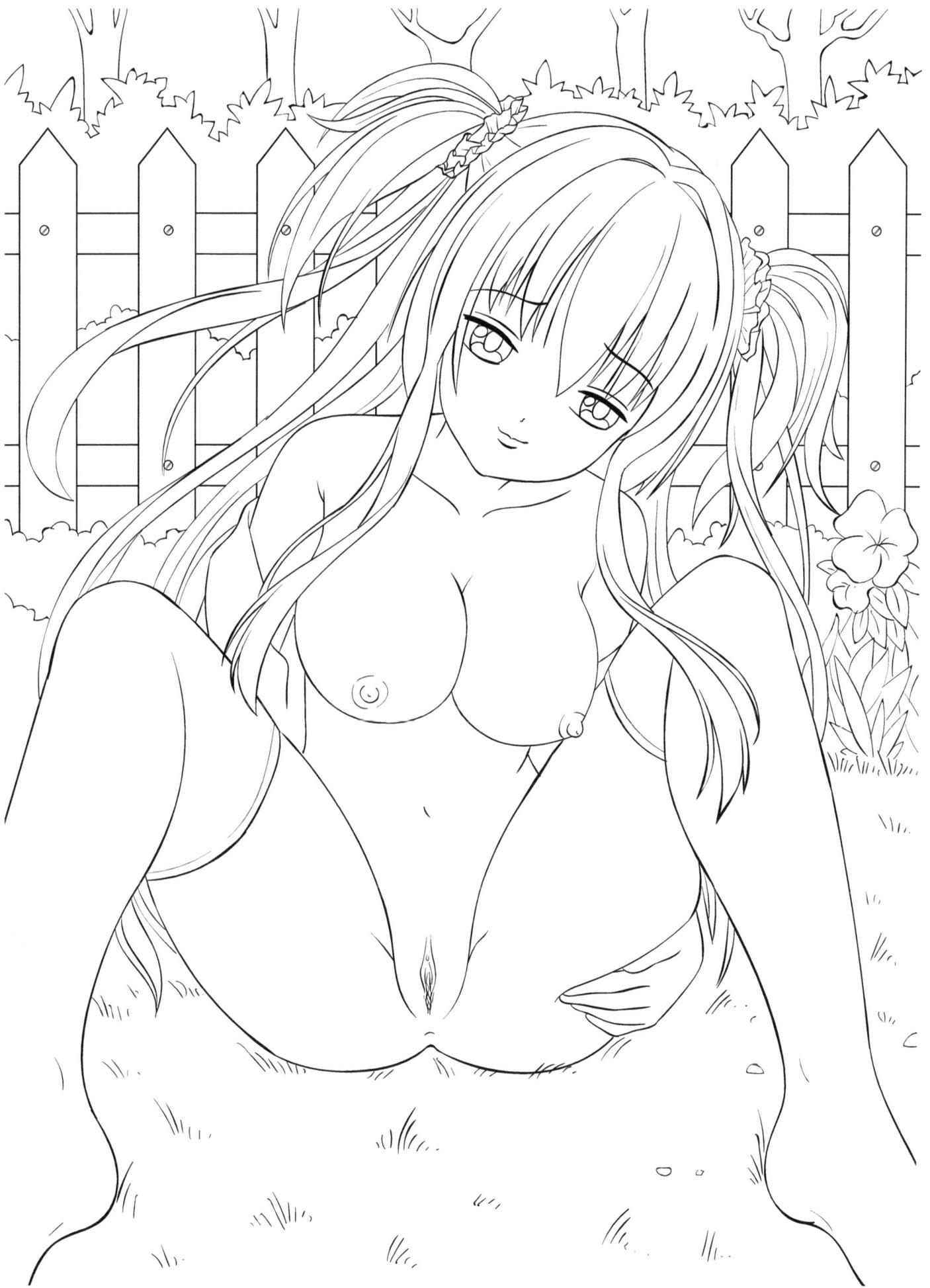

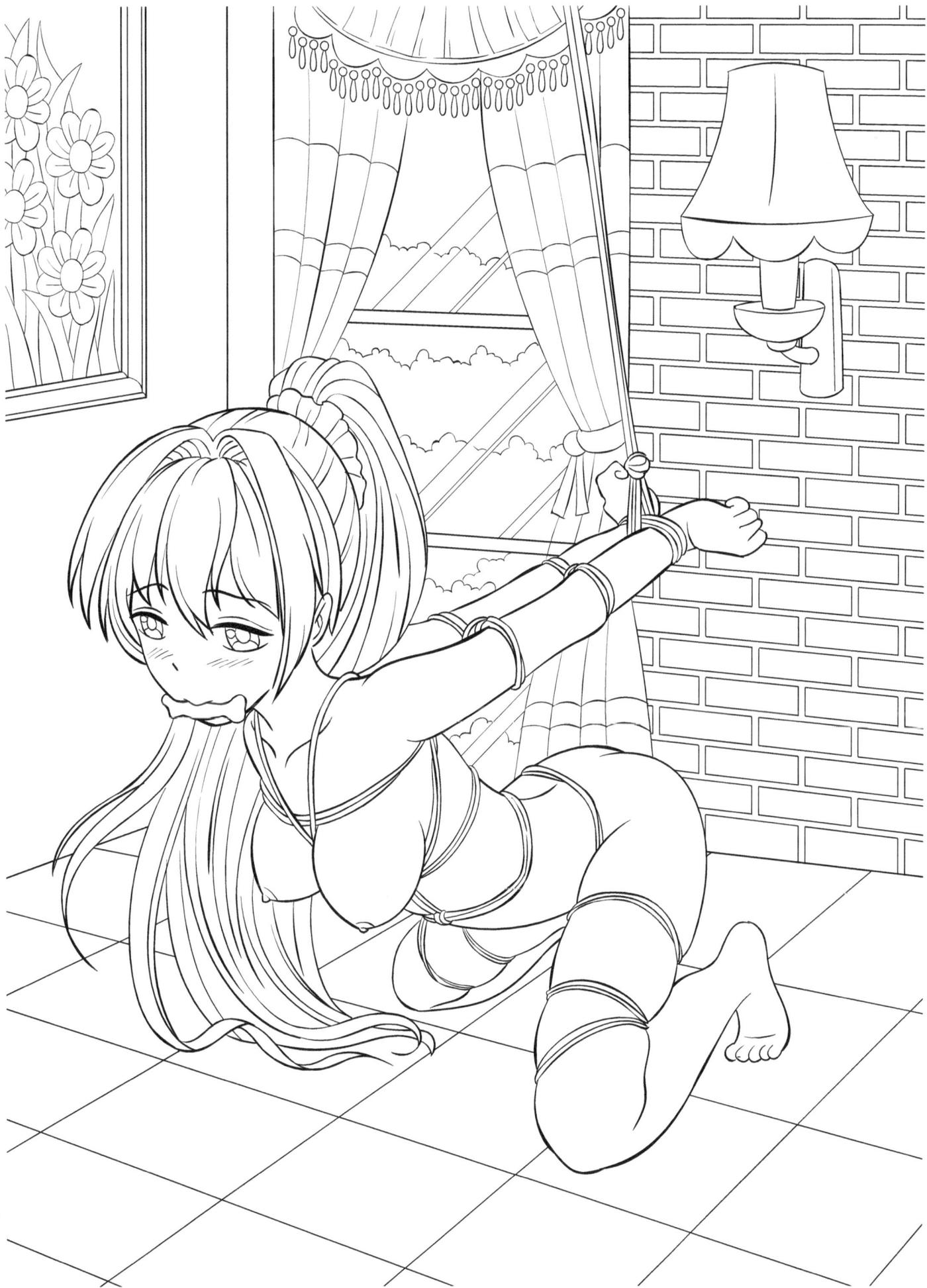

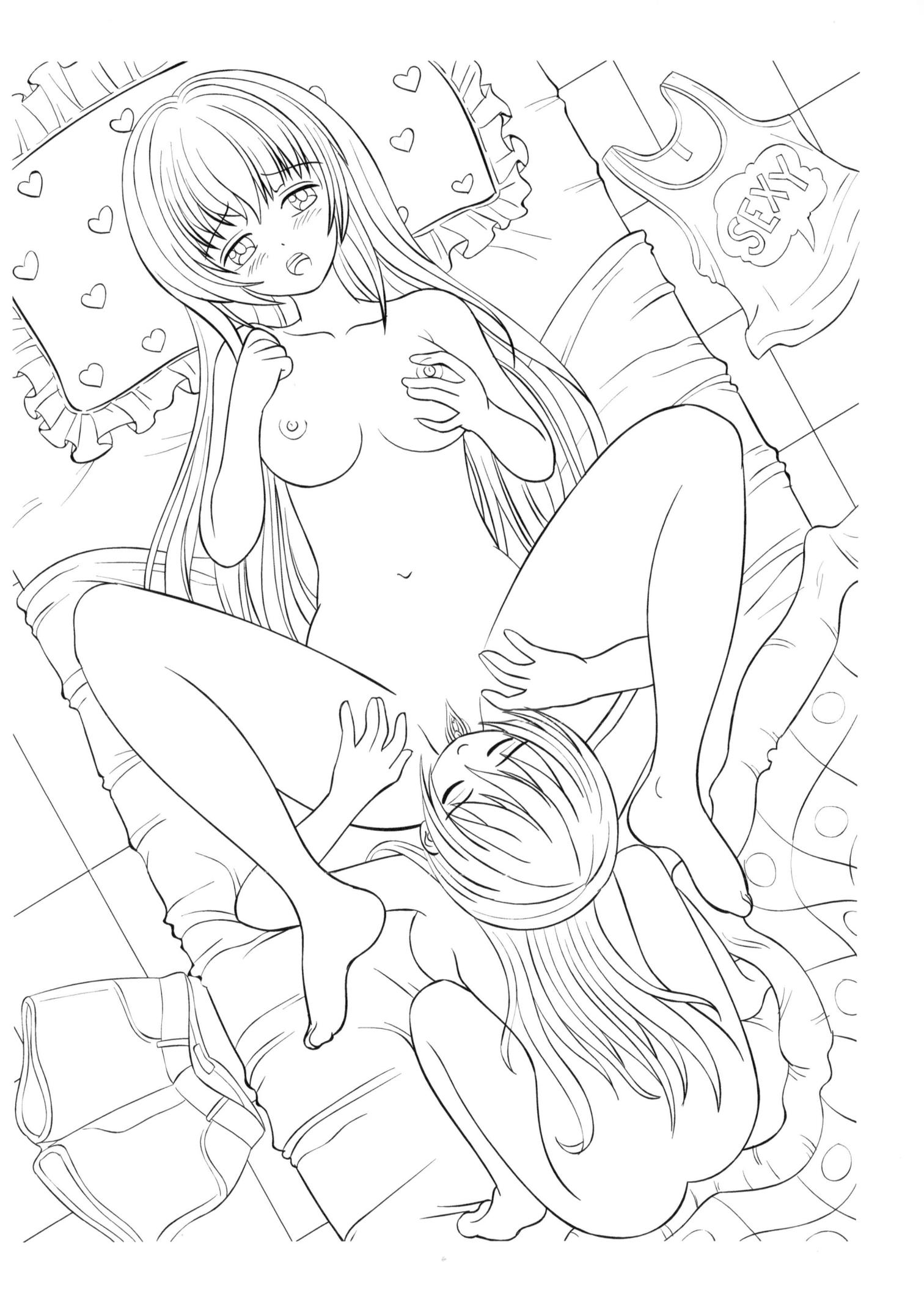

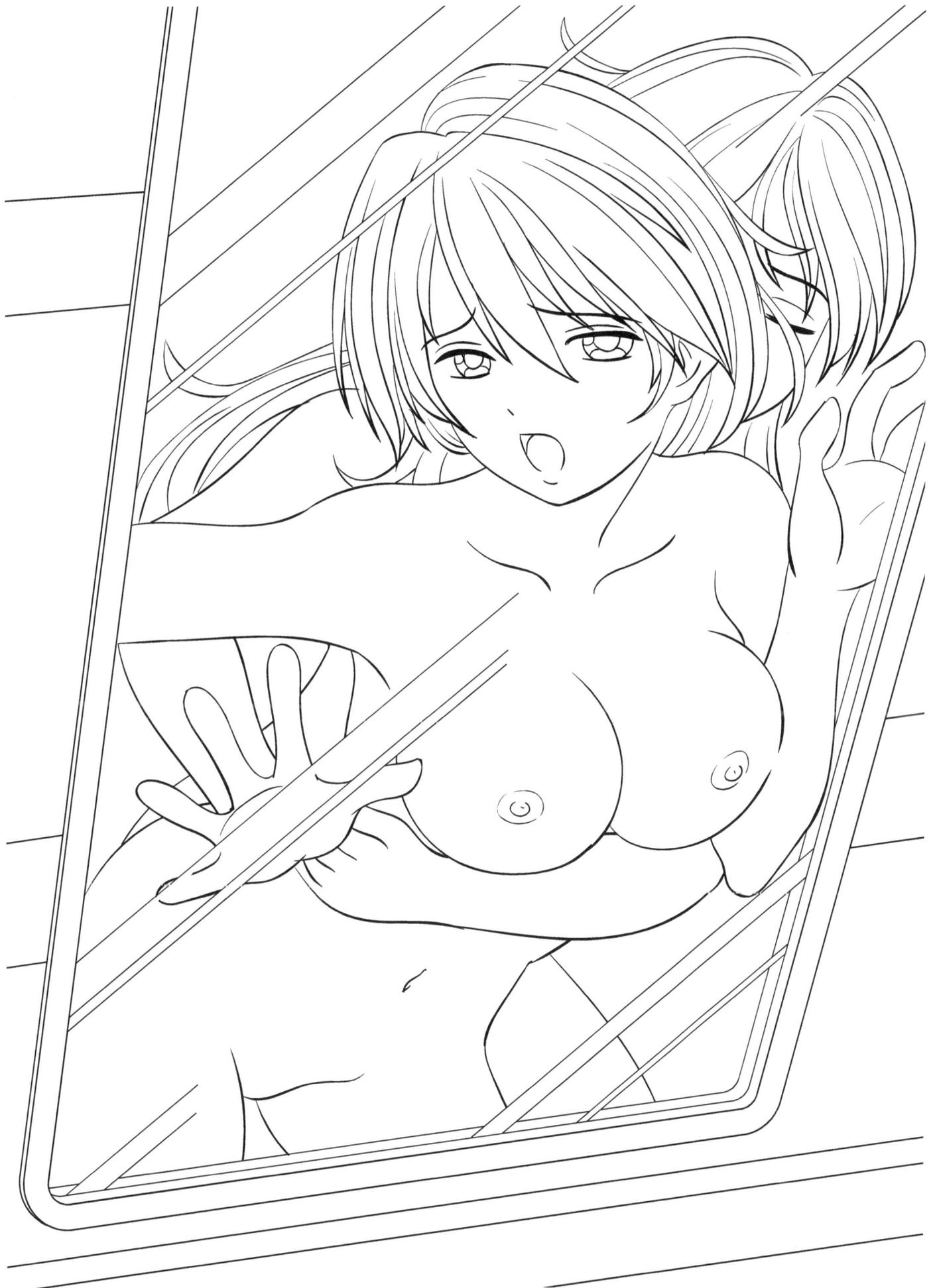

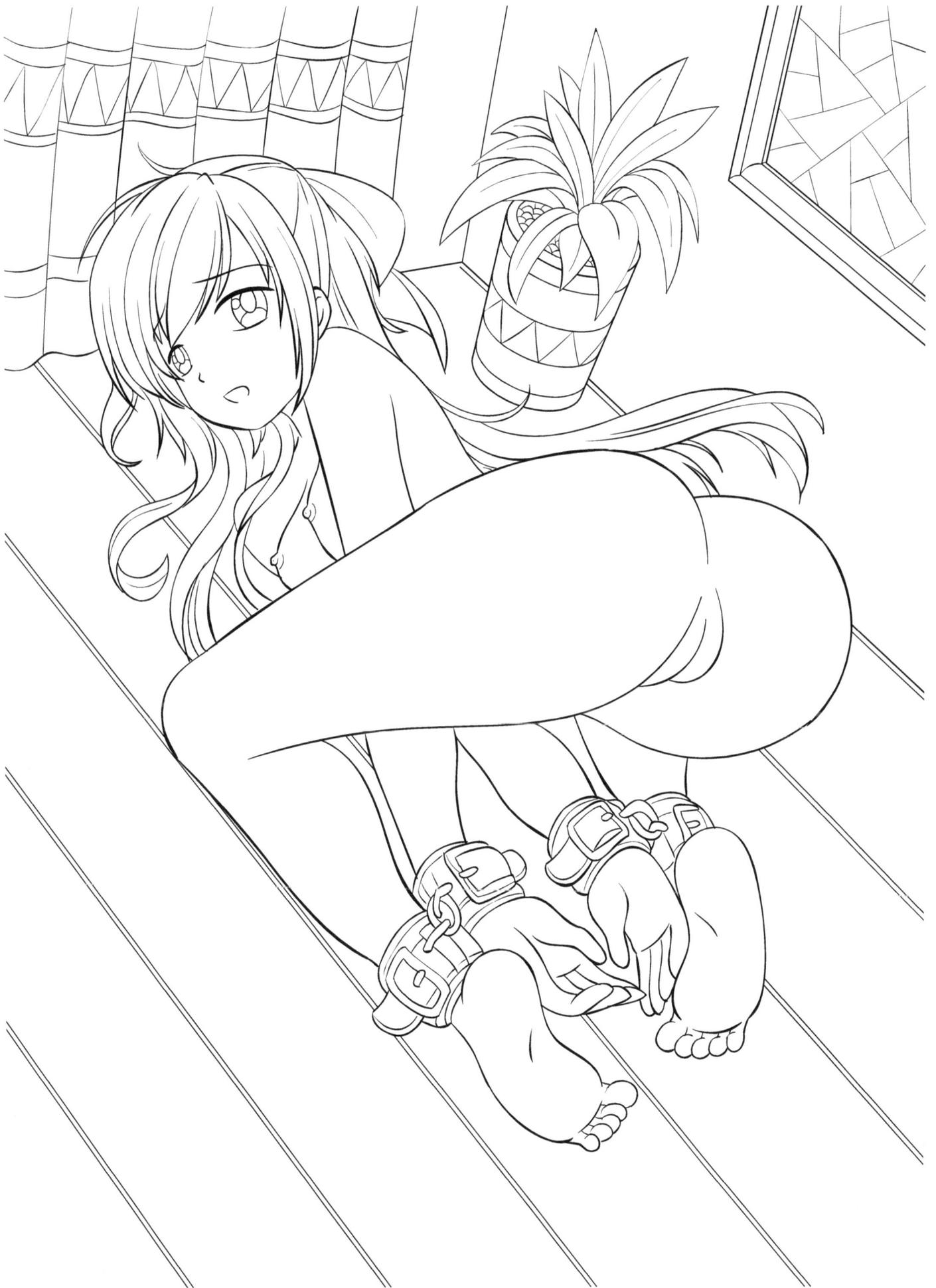

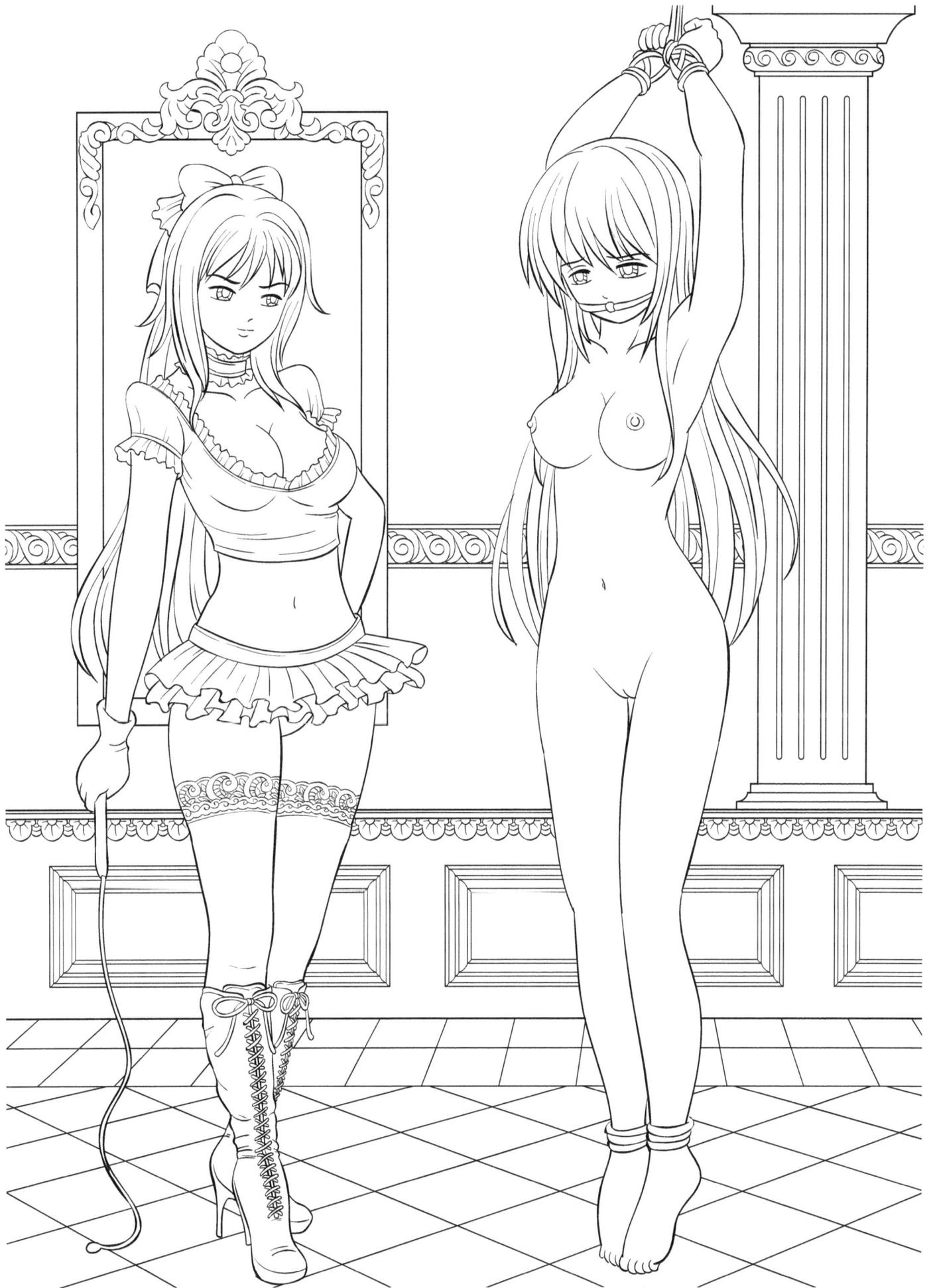

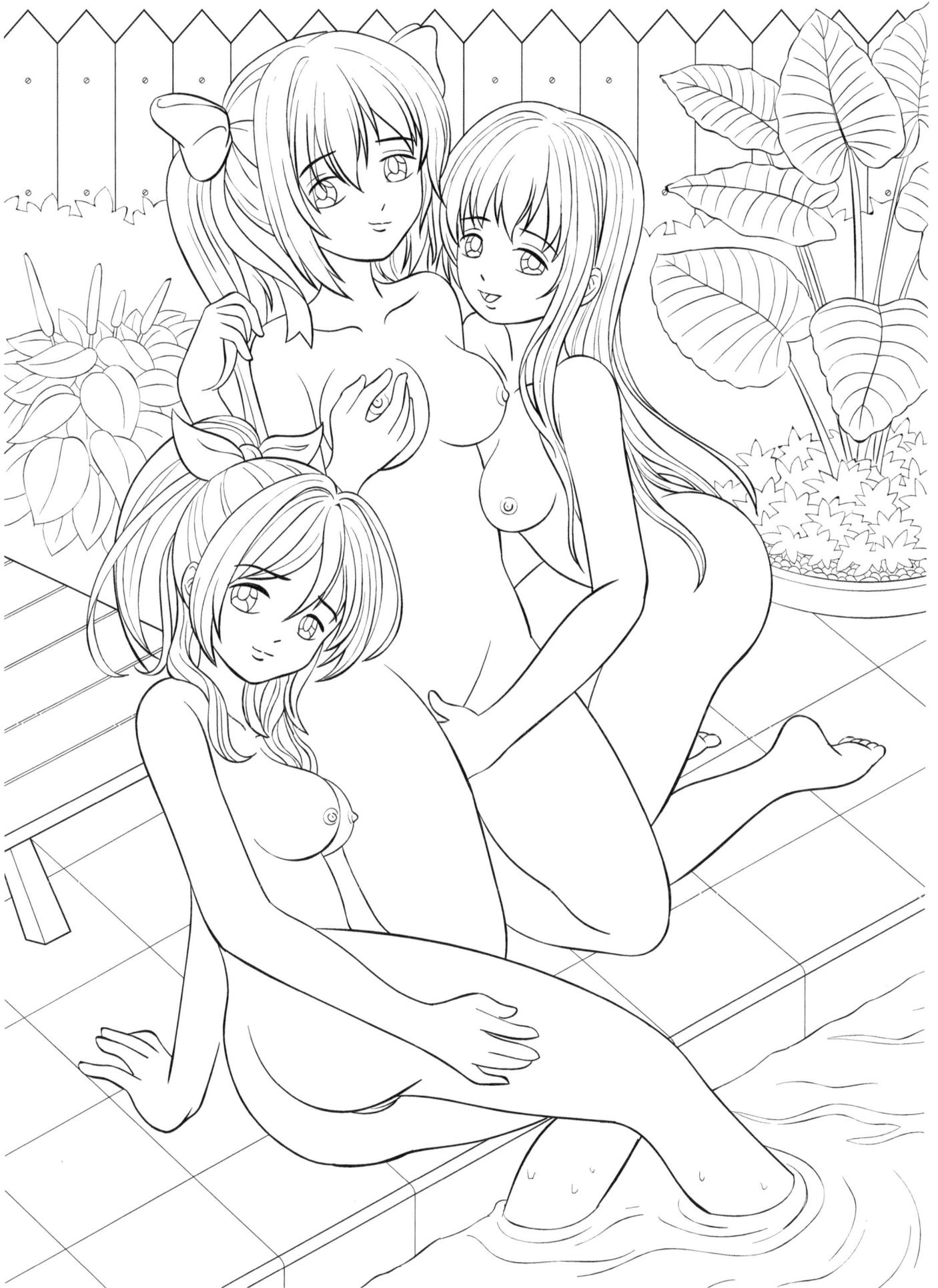

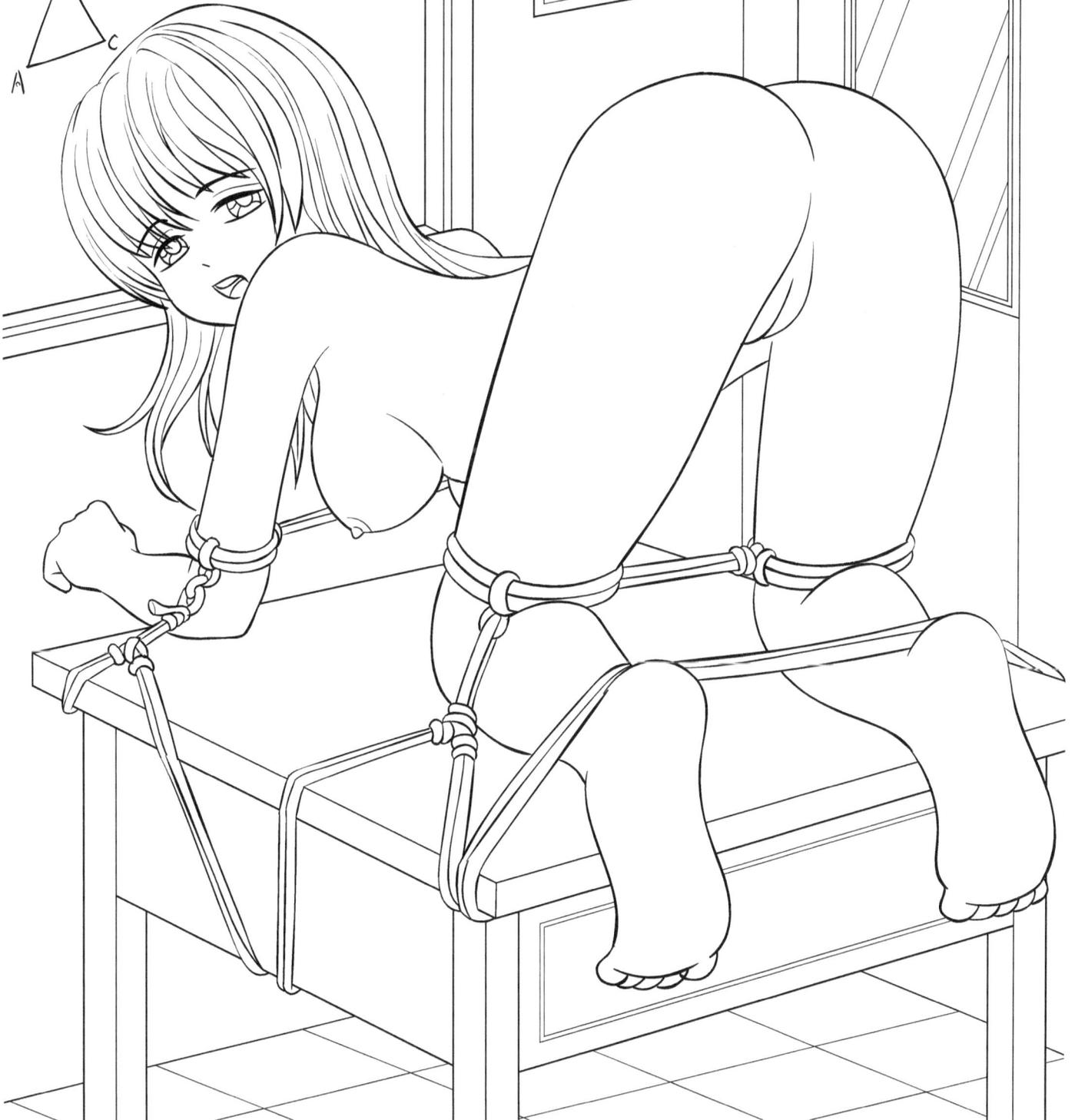

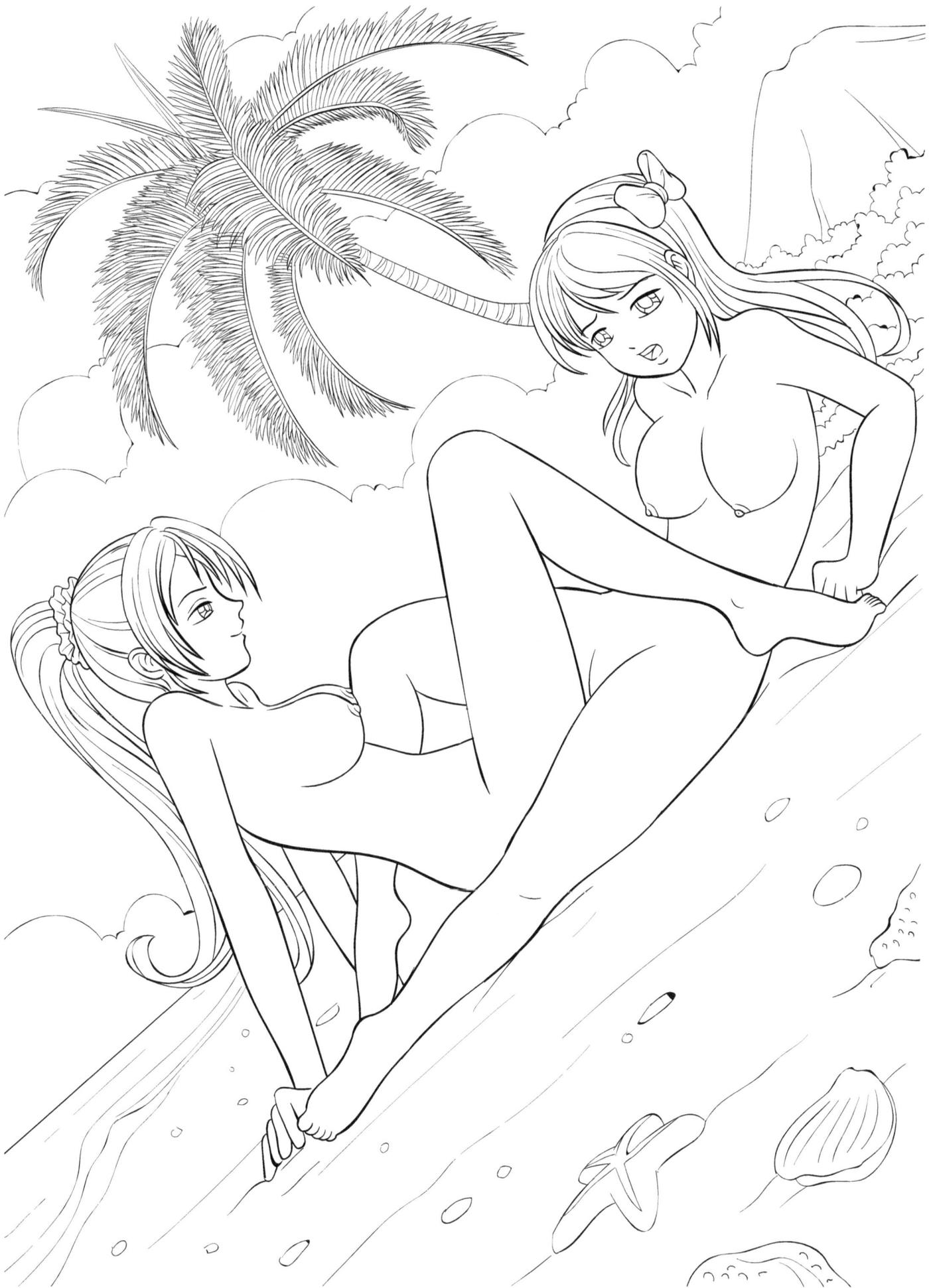

www.ingramcontent.com/pod-product-compliance
Lightning Source LLC
Chambersburg PA
CBHW081153270326
41930CB00014B/3142